ADOBE PHOTOSHOP
LIGHTROOM 2
HOW-TOs
100 ESSENTIAL TECHNIQUES

CHRIS ORWIG

Adobe Photoshop Lightroom 2 How-Tos
100 Essential Techniques

Chris Orwig

This Adobe Press book is published by
Peachpit.

Peachpit
1249 Eighth Street
Berkeley, CA 94710
510/524-2178
510/524-2221 (fax)

Peachpit is a division of Pearson Education.

For the latest on Adobe Press books, go to www.aadobepress.com
To report errors, please send a note to errata@peachpit.com

Project Editor: Susan Rimerman
Technical Editor: Sean McCormack
Copy Editor: Elaine Merrill
Production Editor: Tracey Croom
Composition: ICC MacMillan Inc.
Indexer: James Minkin
Cover and Interior Design: Mimi Heft
Cover Image: Shutterstock

ISBN-13: 978-0-321-52637-3

ISBN-10: 0-321-52637-6

9 8 7 6 5 4 3 2 1

Printed and bound in the United States of America

Dedication

To my three favorite girls – my wife, Kelly, and our daughters, Annika and Sophia

Acknowledgments

Thanks to an amazing editorial team: Susan Rimerman, Sean McCormack, Adam Pratt, Elaine Merrill, and Tracey Croom – it has been a privilege working with you. Susan, you made the process a breeze. Sean, your knowledge of Lightroom is inspiring. Adam, you are a great friend and I appreciate that you found the time to contribute chapters 14 and 16 to this book between family commitments, running marathons, and working at Adobe.

Finally, a special thank you to my colleagues, the professional photography faculty at the Brooks Institute in Santa Barbara, California, for their boundless inspiration. And thanks to the administration for their tremendous support and ability to empower us to be the best and brightest!

Contents

CHAPTER ONE

Getting Started

Since its 2007 debut, Adobe Photoshop Lightroom has emerged as one of the most essential workflow tools ever created for photographers. Whether you are an amateur or a seasoned professional, if you're interested in learning how to manage, create, and present more communicative and compelling images, this book is for you!

Adobe Photoshop Lightroom 2 How-Tos approaches Lightroom from a professional photographic perspective. In other words, you will learn like a pro how to best use Lightroom to revitalize your photographic workflow and, ultimately, to create images with impact. The techniques in this book are designed not just to increase your technical knowledge, but also to increase your ability to create more memorable and lasting images. My hope is that the 100 clear and concise techniques that are presented in this book will catapult your photographic effectiveness and creativity to new levels.

Let's get started!

#1 Understanding the Lightroom Context

The arrival of digital photography in the 1980s was met with a mixture of excitement and skepticism. Many asked, "How can digital ever be better than film?" The early doubts soon gave way to an overwhelming tide of excitement about the quality and creativity provided by digital capture. Yet just as many of the analog photographer's old problems were being washed away by the digital solution, new issues were creeping into the digital photography workflow.

In particular, the sheer volume of digital files and the time intensiveness of digital post-production started to bog photographers down. They needed a tool that would provide a new way to manage, process, and distribute their images. It was in response to this emerging need that Lightroom was created, software designed to be one easy application for managing, adjusting, and presenting large volumes of digital photographs so that people could spend less time in front of the computer and more time behind the lens.

As an instructor of Lightroom, I often hear, "OK, that sounds great, but what does that actually mean—and is Lightroom essential?" My answer is a resounding *yes*. But it's important to realize that Lightroom will not solve all your problems. Lightroom will dramatically improve your effectiveness and creativity but it is not the final stopping point; it is an integral part of the adventure of image making.

I love the great outdoors, so let's compare Lightroom to backpacking. The first time I went backpacking in the mountains, I used a low-quality pack. As a result, my back hurt and I had difficulty accessing my gear. Thus, I didn't fully enjoy the adventure. Since then, I've used an amazing high-end backpack that evenly distributes the weight of the gear. It's comfortable, and I can easily get to my supplies. The end result: I hike longer, farther, and faster, and I enjoy the journey so much more! Lightroom is like the high-end backpack. It frees and enables me to do the job of a photographer, which is to create compelling and breathtaking photographs. Is Lightroom an essential part of my workflow? You bet!

Finally, keep in mind that Lightroom is actually called Adobe Photoshop Lightroom and is part of the Photoshop family. In simple terms, this means that while Lightroom stands strong on its own two feet, when needed it also works incredibly well with Photoshop—and the combination of both of these tools will help you become a creative powerhouse.

#2 Lightroom and the Photographic Workflow Puzzle

The digital photographic workflow can be a bit puzzling at first, especially because there are so many different ways of doing things. In light of this, I am often asked, "How does Lightroom fit into the workflow puzzle?" For starters, there is some good news. Lightroom not only fits into the workflow, it actually spans the entire breadth of the workflow. Before getting too far ahead, let's first define the complex pieces of the workflow puzzle by distilling it to a few essential elements: capture, import, organize, process, archive, and output (**Figure 2**).

Figure 2 A typical digital photographic workflow process extends from capture to output.

In capture, the initial stage, Lightroom can be used when shooting tethered, that is, when shooting with your camera connected to your computer. Lightroom can then automatically begin to catalog and import the images into the Lightroom database. Otherwise, if you're shooting untethered (which is more typical) Lightroom can be used to import the files from a compact flash card onto an internal or external hard drive.

Once the images are on the hard drive, the organization, image processing, and archiving can begin. At this point, you may also need to export an image to Photoshop for creating a more specialized effect. After you edit the image in Photoshop, the file will automatically be integrated into the Lightroom database. Finally, Lightroom can be used to output images for displays in slideshows, PDFs, as prints, or on Web sites. As you can now see, Lightroom is integral to the entire workflow.

#3 The Five Rules

Lightroom's simplicity and elegance are a breath of fresh air amidst the clutter that occupies so much of the digital domain. Therefore, it's no wonder that just as there are five elements and five senses, Lightroom comes with five simple rules. To view the rules choose Help > The Five Rules.

Rule 1—Module Picker

Lightroom is divided into five different modules that allow you to perform different tasks in your photographic workflow. The five modules are Library, Develop, Slideshow, Print, and Web. Click one of the module navigation buttons (**Figure 3a**) to choose the appropriate module. For more information about the modules see Technique #4.

| Library | Develop | Slideshow | Print | Web |

Figure 3a Clicking the module navigation buttons will give you access to different panel contents for different tasks.

Rule 2—Panels

The panels on the left- and right-hand sides of the Lightroom interface (**Figure 3b**) are used to access file information, presets, tools, and more. Each module has a different set of panel contents. In the panels, each section has a header; click this header to hide or show the section content.

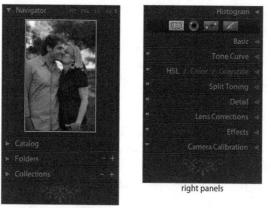

left panels

right panels

Figure 3b The close-up screen shots show the left- and right-hand panels of the Develop module. The majority of your time in Lightroom will be spent using the panels to access tools needed to accomplish the specific task at hand.

Rule 3—Filmstrip

The Filmstrip (**Figure 3c**) is at the bottom of the screen. It provides a view of the photos currently in the Library grid, the contents of a selected folder or of a collection, and the photo selection filters. To change the contents of the Filmstrip, return to the Library and select new images in a folder or collection. To choose a photo from the Filmstrip click the thumbnail or press the right and left arrows.

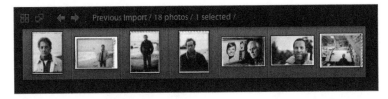

Figure 3c The Filmstrip provides a quick and consistent way to select images to be viewed or worked on in the different modules.

Tip
In the Library and Develop modules, hover over a thumbnail in order to see a larger preview in the Navigator panel.

Rule 4—Important Key Commands

The good news is that whatever your preference is for shortcuts, you'll find Lightroom key commands to be refreshing simply because there aren't that many. While Photoshop has hundreds, Lightroom has only dozens. Therefore, if you want to speed up your workflow you will definitely want to learn the following:

Key Command	Function
Tab	Hide or show side panels
Shift-Tab	Hide or show all panels
F	Cycle full screen mode
L	Dim the lights
~	Flag the selected photo(s)
Ctrl -/ (Windows) or Command -/ (Mac)	View module-specific shortcuts

Panels Navigation— Solo Mode

The default setting for the panels allows you to open more than one panel section at a time. When multiple panel sections are open, you must use the scroll bar. To increase your navigation efficiency, try changing the panel mode to Solo, opening only one panel section at a time. Your panel sections will stay compact and you will not need to use the scroll bar. To turn on Solo mode, Alt-Click (Windows) or Option-Click (Mac) on the triangular arrow or anywhere in the panel section header.

Rule 5—Enjoy

Enjoyment should be an integral component of everyone's photographic workflow. This idea became clear to me when I had lunch recently with photographic legend Douglas Kirkland. Kirkland has photographed more celebrities than you can imagine—everyone from Marilyn Monroe to Nicole Kidman. During our visit, what struck me most was his absolute passion for photography. Douglas and other seasoned photographers simply love what they do. And if you want to become a better photographer, photograph more of what you love.

#4 The Lightroom Modules

Lightroom was designed to be a tool kit for digital photographers. Its creators equipped it with different modules for dealing with different stages of a photographer's workflow.

To make this abstract idea a bit more concrete, consider a family that is looking to buy a new home. The family's core motivation is to find the perfect house. The family evaluates the main rooms (modules) of the house. There is a kitchen for cooking, a dining room for eating, and so on. While all the rooms are interconnected, each room is at the same time unique.

In the same way, Lightroom is a cohesive tool kit, with five different and distinct modules (**Figure 4**). While one of the advantages of Lightroom is the ease of being able to jump between these distinct modules, it is critical to remember that each module is an inherently better place to perform certain tasks. As a result, the more you can understand the strengths or each module, the more effective you will become.

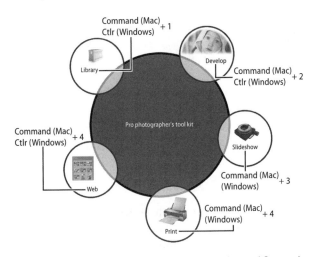

Figure 4 Lightroom was built to be a photographic workflow tool kit for the digital photographer.

Module Sequence

The Library and Develop modules loosely follow a sequential order that mirrors the photographic workflow. It is typically best to start in the Library module. Once you have finished with the organizational tasks in the Library module, you will progress to the Develop module for image editing. After the organizational and editing work is complete, you can select the other three modules: Slideshow, Print, and Web, based on what you need.

Library

The Library module is the natural starting point in Lightroom and in a typical photographic workflow. This module is where all the detail work and organization take place. The Library module's core features enable you to import, export, browse, and search for images, add images to Collections (a user-defined group or set of images), add/modify Metadata and Keywords, rate/rank and sort, and finally, to apply quick processing to the images.

Develop

The Develop module is the second module and definitely the next place to go after you have finished your work in the Library module. It is here that you perform the majority of the image processing and editing. With the Develop module's core features you can do the following globally: apply presets, make a wide range of color and tonal adjustments, apply sharpening and noise reduction, crop and compose, and rank/rate and sort the images. At the same time, you can make local adjustments to specific areas of an image that include modifying color, exposure, tonality, saturation, and clarity.

Slideshow

The Slideshow module is used to create and export a slideshow of selected images. In this module, you have the ability to determine composition and design of the slideshow images and any text or logo. You can create a compelling display of your work while hiding the Lightroom interface so that the focus is solely on each image.

Print

The Print module gives you the ability to create both functional and high-quality prints. You can use the Print module to print preset or custom-designed contact sheets, draft prints, or multiple images on one page in order to maximize the use of your printing resources. At the same time, using custom settings you can create the highest quality prints without ever having to leave Lightroom.

Web

The Web module empowers you to get your work online in a quick and compelling manner. Choose a preset HTML or Flash Web gallery that you can customize with your own copy, logo, and color choice. Next, use the Web module's built-in feature that allows you to upload your work live to a server to share with others or for client review.

#5 Setting Preferences

To open the Preferences dialog choose Edit > Preferences (Windows) or Lightroom > Preferences (Mac). In most circumstances, the majority of the preinstalled default preferences will suffice. Here I will discuss a few of the more important preferences in order to help you determine what will work best for your particular workflow. The preferences are grouped into different sets that can be accessed by clicking the tabs at the top of the dialog window.

General

Click the General tab to open the first set of options, which are for the general preferences (**Figure 5a**). The two most significant preferences have to do with updates and catalogs.

First, in order for Lightroom to be the most relevant and effective tool possible, it is updated frequently by Adobe. While some of the updates are minor improvements, others are significant new features. Be sure to check the option called Automatically check for updates. Then your version of Lightroom will always stay up to date.

Second, choose the catalog option that best suits your needs. If you are working with one main catalog, select Load most recent catalog in order to open the catalog that was in use when Lightroom was last opened. On the other hand, if your workflow requires you to have multiple catalogs, click the pull-down menu and choose either Prompt me when starting Lightroom (in order to pick a specific catalog) or simply select the catalog you want.

Figure 5a In the General Preferences, be sure to select Automatically check for updates and also to specify your catalog preference.

Presets

Click the Presets tab to open the preset preferences. Here is where you can modify default Develop and preset Develop settings. Keep in mind that the presets in Lightroom allow you to save specific settings that you can apply to multiple images. While these settings are helpful, it is easy to inadvertently make a mistake while selecting them. There is no need to worry, however, as you can easily restore the default Lightroom settings in this dialog box.

In the Default Develop Settings (**Figure 5b**), check the option to Apply auto tone adjustments if you would have Lightroom analyze the images and automatically correct exposure and tonality. Typically, I recommend you do not select this option, as it is best to customize the exposure and tonality. Instead, check the option for Apply auto grayscale mix to provide yourself with a starting point when converting to grayscale.

In the lower section of the Presets dialog, select Store presets with catalog in order to share the presets if you will be accessing catalogs on multiple computers. Finally, to restore any of the presets in Lightroom, click the appropriate button. Use this option with care, as clicking on this setting will remove and reset all presets.

Figure 5b In the Presets preferences you can specify your default preset options or reset the Presets to the default settings.

Import

Click the Import tab to open the importing preferences. Select Show import dialog when a memory card is detected to automatically begin the process when you connect a memory card. When you import images with Lightroom, you have an option to convert your files to the DNG format (for more on the DNG format see Technique #13, Understanding File Formats). If you choose this option you will want to set your preference here. The default settings shown the screen capture below (**Figure 5c**) will suffice. If you are concerned about losing the original raw file, be sure to select Embed Original Raw File. Note that choosing this option with dramatically increase your file size, but it will provide you with both a new DNG and the original raw file.

Figure 5c The default import preference settings.

Export

One of the many advantages of using Lightroom is that it works seamlessly with Photoshop. And if you are serious about creating stunning photographs, you will definitely want to tap into many of the strengths of Photoshop or other external editing programs. Click the External Editing tab to access the preferences. Because Lightroom was designed for high-end use, the default settings provide you with the File format, Color Space, Bit Depth and Compression that will lead to the best results. Whether you are a professional photographer or just want the highest

professional results, leave the default settings as they are (**Figure 5d**). On the other hand, these high-quality settings can cause your computer's performance to slow down. If this becomes a concern, change the bit depth to 8 bits/channels to speed up the process.

Preferences Shortcut

To open the Preferences dialog quickly, use the shortcut: Ctrl + , (Windows) or Command + , (Mac).

Figure 5d The default External Editing dialog.

Note

For details about Interface preferences, see Technique #6.

#6 Customizing the Interface

In a recent conversation, accomplished architect Mat Gradias said to me, "I've built my career on the idea that space matters and I wholeheartedly believe it *really* does matter." And I agree with Gradias, especially when it comes to working on photographs in a software application. The space or context that surrounds the images has the ability to direct your opinion about the work. I find it helpful to customize the interface so that I can create a space where I feel at home and where my images take center stage.

In order to customize the interface choose Lightroom > Preferences. Click the Interface tab to access the Interface Preferences for Panels, Lights Out, Background, Filmstrip, and Tweaks (**Figure 6**).

Figure 6 The default Interface preference settings.

Panels

From more than a dozen options, choose a Panel End Mark that fits your photographic style. Keep in mind this is not simply about adding a graphic for graphics' sake. Rather, customize the interface to create a work environment where your images will shine. Next, determine the Panel Font Size.

Tip
Choose the Small panel (default) font size to diminish the size of the panel and increase the potential viewing area for the images.

Lights Out

The Lights Out mode enables you to dim, black out, or brighten the Lightroom interface so that your photo stands out on screen. Choose a Dim Level of 50, 70, 80, or 90 percent and choose a Screen Color that ranges from white to black. In this way you can turn the lights *out* or *on* and really focus on the photo without the distractions of the interface.

Tip

Press the L key on your keyboard to toggle through the various Lights Out modes.

Background

Most introductory photography courses will teach you that if you surround an image with black the colors will appear more saturated and the tone will appear to have more contrast. On the other hand, surround an image with white and you will notice the opposite effect. In Lightroom, choose a background Fill Color and Overlay Texture that will work best with your images. Try different options to discover your own personal preferences.

Tip

In the Library and Develop modules, right-click on the background to access other options that allow you to change the fill color.

Filmstrip

The Filmstrip is a quick and easy way to access and view images. I recommend you leave all of the Filmstrip options selected in order to view and access important information and speed up your workflow. In particular, select Show ratings and picks in filmstrip and also Show badges in filmstrip in order to see helpful small icons. Select Show photos in navigator on mouseover in order to view an image preview in the navigator panel. Finally, select Show image info tooltips in filmstrip to view file name, size, and date.

Tweaks

Select Zoom clicked point to center in order to re-center and zoom the image. In this way, you are able to more quickly zoom into a desired portion of the image. Uncheck this option for zooming where the center point does not change. Select Use typographic fractions in order to change how the shutter speeds are displayed in the metadata panel.

#7 Basic Color Management

Color management is currently a hot topic for photographers—and rightly so. In order to have an effective digital photographic workflow, it is critical to create a color-managed system. In other words, photographers need a system where the color is predictable and reproducible for professional looking results. A color-managed workflow ensures that the color you capture and then see on the monitor is effectively reproducible on the Web, in print, etc. Still not convinced? Well, ultimately, color management frees up the photographer to focus on the content and takes the guesswork out of different forms of output.

The most important consideration in beginning to create a color-managed workflow is to calibrate your monitor so that the colors you see on the monitor will more closely match the colors you see in the final print. The most effective way to calibrate and profile your monitor is to use a colorimeter or spectrophotometer, which are devices that actually measure color samples on your monitor. The devices will allow you to build a profile that will ultimately lead to creating more-color-correct prints. There is a wide selection of calibration kits available, ranging in price from a few hundred dollars to a few thousand dollars. While there are many good options, my personal preference is the X-Rite calibration kit, as you can see in the image below (**Figure 7**).

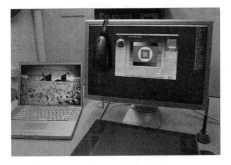

Figure 7 Use a colorimeter to ensure color consistency between the monitor and printer.

Lightroom, Raw files, and Color Profiles

A color profile defines the color space and color gamut of an image. This may sound confusing. Think of color profiles like tags on T-shirts. The tags identify certain characteristics of the T-shirt that help you know how to use it. In other words, if the tag reads medium and you're a medium-sized person, you know it will fit. In Photoshop it is critical to define color workspaces and to tag files.

In Lightroom color workspaces and profiles are not critical. In fact, if you are working on raw images, there is no need to worry about color workspaces or profiles because the color management of these files is taken care of by the internal raw processing engine in Lightroom. It is as if Lightroom is taking care of all the tagging for you.

Tip
When calibrating a CRT or LCD monitor, both Windows and Mac users should set the gamma to 2.2 for the best results. For a CRT set the color temperature to 65k. For a LCD set the color temperature to Native. The color and tone of your monitor will change over time. If you are using a CRT monitor it is recommended that you calibrate it weekly. If you are using an LCD it is recommended that you calibrate it monthly.

#8 Speed Shortcuts

While we have already covered some essential keyboard shortcuts in Technique #3, this technique is dedicated to highlighting a few more shortcuts that will make you even more effective. The shortcuts list below is in no way exhaustive, but is a collection of some of the more common shortcuts that I use.

Rating

One of the first steps in any photographic workflow is to rank and rate the images. Once you've tried using the shortcuts below you won't ever go back to anything else. First, use the arrow keys to select an image, and second, press a number between 1–9 to add a rating or color label for quality, importance, or category (as detailed below).

Key Command	Function
< >	Select a new image
1–5	Set Ratings
6–9	Set Color Labels

Interface

The Lightroom interface is designed to be simple and elegant. Yet, even with its simplicity, it can get in the way. It is important to minimize the interface in specific ways in order to open up more space for both the task at hand and for viewing the images in an uncluttered environment. Here are some ways to do that.

Key Command	Function
F5	Hide/Show Identity plate and Module Picker
F6	Hide/Show Filmstrip
F7	Hide/Show left panel
F8	Hide/Show right panel
Tab	Hide/Show left and right panels
Shift + Tab Hide/Shot	all panels
T	Hide/Show the Toolbar

Modules

Being able to navigate quickly between the different modules is critical. Fortunately there are a number of different shortcuts for selecting a module. Use the shortcut that works best for you.

Key Command	Function
Ctrl + Alt + 1 (Windows) or Command + Option + 1 (Mac)	Library module
G	Library module—Grid View
E	Library module—Loupe View
Ctrl + Alt + 2 (Windows) or Command + Option + 2 (Mac)	Develop module
D	Develop module
Ctrl + Alt + 3 (Windows) or Command + Option + 3 (Mac)	Slideshow module
Ctrl + Alt + 4 (Windows) or Command + Option + 4 (Mac)	Print module
Ctrl + P (Windows) or Command + P (Mac)	Print module
Ctrl + Alt + 5 (Windows) or Command + Option + 5 (Mac)	Web module

Panels

After you have selected the module that you would like to work in, the next step is to choose one of the specific panels inside the module (**Figures 8a** and **8b**). For example, press the D key to navigate to the Develop module. Next, to work on the detail of the image, click the word Detail to open up that panel. While this approach works, it can be time consuming to continually click to open the various panels. To speed up your workflow, try using the shortcuts listed below, which work in all five of the modules.

To open/close the Panels on the left press:

Ctrl + Alt + 1-6 (Windows) or Control + Command + 1-6 (Mac)

Note the shortcuts for the left-hand Develop module panels (**Figure 8a**).

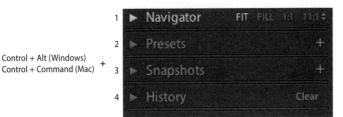

Figure 8a Develop module left panel shortcuts.

Open Shortcut Menu

Each of the separate modules has a distinct set of valuable shortcuts. To view the different shortcuts, navigate to the module and then press Ctrl + ? (Windows) or Command + ? (Mac). This will open a shortcut menu specific to the module that you are currently in. To close the menu simply click anywhere on the screen.

To open/close the Panels on the right press:

Ctrl + 1-7 (Windows) or Command (Mac) + 1-7

Note the shortcuts for the right-hand Develop module panels (**Figure 8b**).

Control (Windows)
Command (Mac) +

1	Histogram
2	Basic
3	Tone Curve
4	HSL / Color / Grayscale
5	Split Toning
6	Detail
7	Lens Corrections
8	Camera Calibration

Figure 8b Develop module right panel shortcuts.

Note

While the screen captures show only the shortcuts to access the specific panels for the Develop module, these shortcuts actually work to access the panels of all of the various modules.

Key Command	Function
Ctrl + Enter (Windows) or Command + Return (Mac)	Enter Impromptu Slide-show mode
F	Cycle to next Screen mode
L	Cycle through Lights Out modes

#9 Hardware Considerations

Lightroom is a software application designed to make you a more effective digital photographer. In order to take advantage of good software you need good hardware. So the question arises, "What computer and hard drive setup are best in order to take advantage of Lightroom's capabilities?" At a bare minimum, for your computer you'll need the following:

Windows

- Windows XP SP2

- Pentium 4 processor

- 768 MB RAM (1 GB recommended)

- 1 GB free HD space

Macintosh

- Macintosh OS 10.4 or higher

- G4, G5, or Intel processor

- 768 MB RAM (1 GB recommended)

- 1 GB free HD space

If you are working on a high quantity of large files, or simply want to speed up your workflow, you will want to go above and beyond the minimum requirements. In this case, having a faster processor will help, but the most important improvement you can make is to add more RAM to your computer. Installing more RAM will give you the biggest bang for the buck, and installing RAM is the most cost-effective way to improve Lightroom's performance.

The other important hardware consideration is finding the best hard-drive option for storing your images. While the issue of storage is worth a book in itself, let's at least discuss a few of the major issues.

First, by default Lightroom saves your database catalog on your local hard drive. Keep in mind, the catalog does not contain the images themselves, but rather it contains thumbnail previews and information about the images. Because Lightroom needs to have consistent and quick access to the catalogs, it is typically best to keep this default location.

Hard Drive Speed

To speed up your workflow use external hard drives so that you do not overload your main, internal hard drive. Ideally, your internal hard drive should be only 50 percent full. If the drive is more that 75 percent full the performance of your software can slow dramatically. If you notice that your hard drive is getting full, off-load as much content as you can to external drives. The good news is that external hard drives have never been cheaper—it costs much less to store more.

Second, upon importing new images into Lightroom you can choose to store them on an internal or external hard drive. Where you store your images is really contingent on how prolific a photographer you are. If you are shooting a small volume of images, then your internal hard drive will suffice. If you are like the majority of photographers and you shoot quite a bit, you will want to invest in an external back-up system. There is a wide range of options. The simplest and most common is having multiple external hard drives or, as some call it, JBOD—just a bunch of drives. In this scenario, it is best to put your most recent images on a single hard drive and the older images on other drives that can be powered off in order to lengthen the life spans of the hard drives.

#10 Using Multiple Monitors

In digital photography a computer monitor is like a traditional photographer's desk with a light box. Instead of a table covered with piles of 35mm slides or filmstrips in sleeves, the workspace is a large monitor. Using more than one monitor allows the photographer to have more space to stretch out and focus on the task at hand. In my own workflow, I have a desktop with two monitors and a laptop that connects to an external monitor (**Figure 10a**). Whatever your personal preference, you will find the ability to work in Lightroom on multiple monitors very helpful.

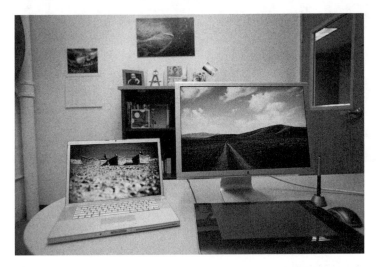

Figure 10a My desk with the laptop connected to an external monitor.

To set multiple monitors, click the small computer monitor icon (**Figure 10b**) to launch the window for your second monitor. Next, click and drag the window to the second monitor. Click the navigation buttons at the top of the screen to select the functionality of the window. Choose among Grid, Loupe, Compare, or Survey. These options function just as they do in the Library module. Next choose Normal, Live, or Locked, based on your viewing preference:

Normal to show the most-selected photo—i.e., the last photo you clicked on.

Live to show any photo you hover your mouse over in the Filmstrip or Grid on the main screen.

Locked to show the current photo until it is unlocked.

Figure 10b Click the small computer icon, which is below the right-hand side panel and just above the Filmstrip, to open the window for your second monitor.

Second Monitor Shortcuts

Use these shortcuts to quickly navigate among the different second monitor functionalities:

Key Commands	Function
Shift + G	Grid
Shift + E	Loupe
Alt Shift + E (Windows) or Option Shift + E (Mac)	Live Loupe
Alt + Enter (Windows) or Option + Enter (Mac)	Locked Loupe
Shift + C	Compare
Shift + N	Survey

#11 Help, How-Tos, Resources, and Training Videos

While the Lightroom curve is not incredibly steep, it is still easy to get lost and need some help. One of the most valuable built-in help tools is the Adobe Help viewer. To launch the help viewer, Select Help > Lightroom Help. You can browse by topic or enter a request in the search field (**Figure 11a**).

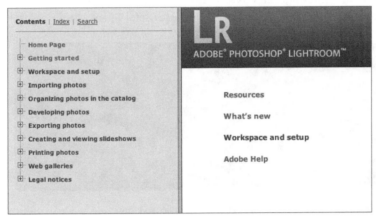

Figure 11a The main screen of the Adobe Lightroom Help viewer.

Another invaluable tool is the free Adobe Lightroom resources. To access these resources choose Help > Help Resources Online (**Figure 11b**).

Figure 11b The top portion of the opening page of Adobe Lightroom resources.

Help Shortcut

Ctrl + ? (Windows) or
Command + ? (Mac)
opens Lightroom Help.

The Adobe Help Viewer and Adobe Help Resources Online are both good sources, but sometimes you need more than text and graphics. Where can you go for more help? Free video-based training movies on Lightroom and the rest of the Adobe product line are found at www .adobe.com/designcenter/video_workshop (**Figure 11c**). Adobe has partnered with Lynda.com to provide these useful videos.

Figure 11c Get more help from the Adobe Video Workshop.

Note
If you are interested in learning more about Lightroom, there is a wealth information on the Web. Try visiting one of the following sites:

- *www.peachpit.com/lightroom—Lightroom resources, books, articles, and tutorials*

- *www.lightroomkillertips.com—Lightroom resources, tips, and inspiration*

- *www.mulita.com/blog—Lightroom and Photography inspiration*

- *http://lightroom-blog.com—Lightroom resources*

- *www.photoshopsupport.com/lightroom—Lightroom resources*

- *http://lightroom-news.com—Lightroom resources*

CHAPTER TWO

Importing Images

As you have now discovered, Lightroom is an application that you can use throughout the entire photographic workflow, from import to output. In this chapter, we will dig into how you can utilize many of Lightroom's features for importing images.

You may be tempted to skip this chapter and jump ahead to the others, which deal with image processing. The time you spend with this chapter will be well worth it to establish a foundation for the rest of your work in Lightroom. To be an effective and creative photographer, it's critical that each and every aspect of your workflow be as strong as possible. Because when you stop to think about it, the worst type of photograph is the one you can't find.

Ultimately, this chapter will help you be at the top of your game. We'll start off by discussing some basics of digital asset management and file formats. Next, we will cover importing options, converting files, adding metadata, auto-importing, and tethered shooting.

#12 Basic Digital Asset Management

All Hard Drives Go to Heaven

The fact that all hard drives will eventually die causes many photographers to lose sleep at night. But backup and storage don't have to be scary. Follow the steps detailed in this technique and you'll be prepared for the unexpected. Plus, with all the extra sleep you will be getting you'll have plenty more time to create amazing photographs.

For photographers, few topics are as important yet as overlooked as digital asset management. This is a quite broad term that refers to the process of dealing with digital assets such as images. For photographers, it means image importing, downloading, renaming, rating, grouping, backing up, archiving, browsing, and exporting. In this Technique we'll cover the basics of image storage on external hard drives.

As mentioned in Technique #9, where and how you store your images is really contingent on how much you shoot. If you take photographs weekly or even monthly, you need a simple yet substantial system for storing and backing up your images. The simplest approach is to use more than one external hard drive.

Many photographers choose this option because it is affordable, flexible, and relatively easy to manage and upgrade. That being said, many photographers blindly buy new hard drives without ever developing a strategic approach to using them.

It is critical to note that hard drives typically "live" for three to five years. Therefore, the question isn't, "Will the hard drive die?" but, "How much longer until the drive dies?" This may sound pessimistic, but your approach to backup storage needs to be realistic. While three to five years is typical, keep in mind that the life span of the hard drive depends on the amount of usage and other wear and tear factors. The fact that all hard drives will die makes having a solid digital asset management strategy critical.

While different strategies will work for different photographers, here are a few general recommendations for storage and backup:

1. Store the Lightroom database catalog on your internal hard drive. This will improve Lightroom's performance. Remember to back up frequently.

2. Purchase external hard drives in multiples of three.

3. Store and back up your files to at least three hard drives.

4. Keep one hard drive at another physical location in case of fire or natural disaster.

Note
There are other viable options for backup, like raid drives, automatic backup, and network backup, but the most common method is to use multiple standard external hard drives.

#13 Understanding File Formats

Lightroom is designed to support a wide range of formats, including RAW, DNG, TIFF, JPEG, and PSD. Before we discuss these specific formats, it is worth discussing how Lightroom deals with files in general. At its core, Lightroom is a raw image processor. What this means is that you are able to make changes to an image without actually changing the image.

When you make changes in Lightroom, the changes are written to a file that is separate from the actual pixels in the original file. Not only is this approach flexible, it generates files that are smaller than other "pixel editing" programs.

Camera raw formats

Raw file formats are the type most commonly used in Lightroom. These files contain raw, unprocessed data, which comes straight from the camera's sensor. Because it is unprocessed, the raw data truly is more flexible than and superior to JPEG data, which goes through a series of processing steps that interpret the data within the camera. This means that with raw files you actually have access to more data, and this allows you to make more significant image modifications, like correcting exposure, recovering highlights, and more. At the same time, it is important to realize that the majority of the camera manufacturers save the camera raw data in company-specific proprietary camera raw formats. Fortunately, Lightroom is capable of reading and processing the camera raw data from most cameras.

DNG format

Adobe has created a unique raw format called the Digital Negative (DNG). This is a publicly available archival format for raw files generated by digital cameras. You can convert any of the supported file types (RAW, DNG, TIFF, JPEG, and PSD) to the DNG format when you import them into Lightroom. Or visit www.adobe.com/products/dng to download the Adobe DNG converter. Ideally, because this format is "open" and not dependent on camera manufacturers, it ensures that photographers will be able to access their files in the future even as formats and cameras change. Of course, it is difficult to envision what the future digital photographic landscape will actually look like, but the DNG format is an appealing solution for those who will need to open and process raw files far in the future.

Camera Raw Support

For a list of supported cameras and camera raw formats, see www.adobe.com/go/learn_ps_cameraraw.

Learn More About DNG

The Digital Negative (DNG) format is starting to gain acceptance. In fact, within one year of its introduction, many software manufacturers had developed support for DNG. Even more, many respected camera manufacturers (Hasselblad, Leica, Ricoh, and Samsung, for instance) have introduced cameras that provide direct DNG support. If you would like to learn more about the DNG file format, visit www.adobe.com/dng.

Lightroom and Large File Support

Lightroom now supports incredibly large documents saved in TIFF format—substantially bigger than previously—with pixel dimensions of 65,000 on a side! This is especially helpful for those who are interested in interpolating images to create extremely large prints.

TIFF format

The Tagged-Image File Format (TIFF) is a widely used unbiased file format. Unbiased means that it works well with other applications and between different computer platforms or operating systems. The format is supported by almost all paint, image-editing, and page-layout applications, including Adobe Creative Suite. One main advantage of using the TIFF format is that it provides greater compression and industry compatibility than the Photoshop format (PSD) and is the recommended format for exchanging files between Lightroom and Photoshop. In fact, the Lightroom default export file format is TIFF. For more on exporting files from Lightroom, see Chapter 8.

JPEG format

JPEG stands for "Joint Photographic Experts Group." It is the most common format used to display photographs and other continuous-tone images on the Web, in slideshows, presentations, and other interactive media. The main advantage of using it is small file size. The JPEG format allows you to retain important color information in an RGB image by selectively discarding some color and tone data and still maintain a good visual quality. The main disadvantage is that the JPEG file format is compressed; therefore, every time you save a JPEG some data is lost. This means JPEG is definitely not a good archival format.

PSD format

The standard Photoshop file format is PSD. Although PSD is the default format, if you are going to work with Photoshop it is actually best to use the TIFF format, as it is more flexible and integrates more easily into Lightroom. You may have old PSD files that you want to import into Lightroom. In this case, to import and work with a multilayered PSD file, the file must have been saved in Photoshop with the Maximize PSD and PSB File Compatibility preference turned on. This option is located in the Photoshop file handling preferences.

#**14** Importing Overview

If you have ever attended a talk or conference session about Lightroom, you've probably heard quite a bit about the software's capabilities to import images into a database. Well, what's the big deal—is all this importing to database stuff really that important? The answer is a definite yes!

For starters, there are six essential digital photography workflow elements: capture, import, organize, process, archive, and output. Lightroom comes into the equation right after capture. In fact, one of the advantages of using Lightroom is that, unlike with Adobe Bridge or other applications, you have the ability to start off your workflow by importing images straight into a database catalog rather than simply browsing the images in huge batches before trying to organize them. While I will cover the details of working with Lightroom database catalogs in Chapter 16, know for now that the main advantage of importing images into a database is speed.

One of the largest problem areas facing the digital photographer involves how to view, access, and organize the images effectively. The results of over-shooting often leave the photographer immobilized or at least a bit stunned. Therefore, speed becomes a premium worth paying for. Fortunately, Lightroom provides an easy, enjoyable, and inexpensive solution to this problem by importing images into its database catalog.

To import your images into Lightroom (and into the Lightroom database catalog) Click the Import button. This will open the Import Photos dialog (**Figure 14a**). When choosing how to handle the files, you have four importing options (**Figure 14b**): Keep the files at their current location, copy photos to a new location, move photos, or copy photos as DNG.

A Quicker Way to Import

Because importing is one of the most common steps you'll take in Lightroom, it is worth learning the shortcut to open the Import dialog. Press Shift + Control + I (Windows) or Shift + Command (Mac) + I to import images into Lightroom.

Figure 14a If you are new to Lightroom, the majority of the default settings will work fine for you, but be sure to specify how to handle the images and to designate a final destination for the images.

Figure 14b Choose the File Import dialog option that works best for you. While all four options import photos, each one works a bit differently.

Note

For more specifics on how to use the Import Dialog features, see Technique #15.

#15 Importing Essentials

In order to get the most out of the Import Photos dialog (under the File menu) to import your photos, let's dig a bit deeper into the more important Import dialog options (**Figure 15a**). This technique is not meant to be exhaustive, but to shed light on the less intuitive and most critical options for your workflow.

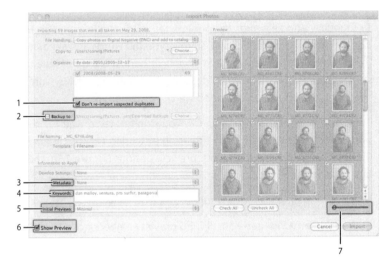

Figure 15a Highlighted and numbered time-saving Import Dialog options.

1. Be sure to select Don't re-import suspected duplicates. This is especially helpful in a couple of scenarios. First, if you have imported images from a compact flash card and then reused the card without deleting the old images, both the images from the previous shoot and the new images are imported into your database. Selecting this option will allow you to ignore duplicate images that have already been imported. Second, you may be uncertain whether you've already imported images. This option will prevent you from adding images twice.

2. To back up your images to multiple locations at the time of import select Backup to: and import your images to a secondary location. Ideally, this location is on another external hard drive. Note: The folders and backup files copied to the external drive will have the same naming conventions as the imported files.

3. By adding metadata presets to your images upon import you can have the metadata available and still save time. To create a new preset, click on the Metadata preset drop-down menu and choose New. Then enter important metadata. To apply the preset simply select it from the drop-down menu. Plus, once you've created a preset, you can edit it as needed.

4. To manually add keywords to your images inside the Information to Apply area of the Import dialog, simply type the words and separate them by commas. When you add keywords here, it is a good idea to start with general keywords that describe the whole import. Keywords specific to the photo can be added later.

5. By selecting this option in advance, you don't have to wait for the preview to be generated when browsing or working on the images. Choose whichever one of the four preview options (**Figure 15b**) that best suits your needs:

Minimal—Small JPEG preview suitable for Grid view mode.

Embedded and Sidecar—Small JPEG preview embedded in the raw or sidecar file. Suitable for Grid or Loupe view mode when you need to quickly preview an image. If you choose this option, Lightroom will render a new preview when the zoom is greater that the embedded preview size.

Standard—Medium JPEG preview suitable for Loupe view mode. These previews are rendered from the raw images during the import process.

1:1—Full size preview, which is rendered using the default sharpen and noise settings. While this is the best preview, it does take longer to render.

```
✓  Minimal
   Embedded & Sidecar
   Standard
   1:1
```

Figure 15b The Import Photos dialog preview options.

6. Select Show Preview in order to see the thumbnails in the Preview pane on the right side of the dialog. By selecting this option you can not only see what images you are importing, but also can determine if any images are not worth importing. To deselect an image so that it is not imported, simply click the check box to the right of the image in the Preview pane.

7. Move the Preview thumbnail slider in order to change the size of the thumbnails in the Preview pane. The maximum viewable size depends on the embedded preview size.

1:1 Preview

In my own workflow, I choose 1:1 preview. While the rendering of this preview does take longer, I find the results worth the wait, as this preview is based on the actual raw pixels rather than the embedded and limited JPEG preview and thus is more accurate. On the other hand, I have colleagues who choose Minimal, as they are most interested in seeing the images quickly. Experiment with various options to determine what works best for you.

#16 Auto Import

As a teacher and workshop instructor, I am often asked, "What's the real difference between Lightroom and Adobe Bridge?" While there are many differences, one of the most important is that with Lightroom you can import the photos and store the photos, photo previews, and metadata much more efficiently. Because this is an abstract concept, I usually provide students with this example: "Using Bridge is like going shopping at grocery store without a cart. You can still see everything but it gets a bit cumbersome when you actually want to take something off the shelf." With Lightroom you are shopping with a cart; importing in Lightroom is like taking an item off the shelf and putting it in your cart. The workflow is simple, fluid, and enjoyable, and you are quickly on your way.

Using Auto Import in Lightroom is like going shopping with a grocery cart and having the items jump automatically into your cart as you walk the aisles of the store. In more technical terms, the Auto Import feature allows you to automatically import photos into the Lightroom database catalog from a predetermined folder. This feature has many uses; for one, it's a simple way to add images while shooting tethered to your computer.

To set up Auto Import, choose File > Auto Import > Auto Import Settings. This will open the Auto Import Settings dialog (**Figure 16a**). First, define the Watched Folder, which is the folder Lightroom looks at for new images to automatically import. Note that this folder needs to be empty in order for Auto Import to work. Second, select the Destination for the images. This is the folder that Lightroom will move the images into as it imports them. Next, select a choice for each of the following options (which are identical to the Import dialog options): File Naming, Develop Settings, Metadata, Keywords and Initial Previews.

Figure 16a Use the Auto Import dialog to enable and specify the Auto Import Settings.

Depending on your workflow, you will find different uses for Auto Import. In some workflows photographers first process their images in the camera manufacturer's proprietary software. In this case, one practical use of the Auto Import feature is to "finish" the images in the software and then drag them to the Watched Folder in order to import them into Lightroom. Another use is to save files from other programs into the Watched Folder, which can then be auto imported into Lightroom. But the most common use of Auto Import is for tethered shooting, which is discussed in Technique #17.

#17 Tethered Shooting

Typically, when a digital camera takes a photo the image is written onto a memory card. In order to preview the image you have to view it on the small LCD screen on the back of the camera. Tethered shooting allows you to write an image directly to a computer so that you can quickly see a large view of it (**Figure 17a**). This is especially handy when you're shooting in a studio (**Figure 17b**). To shoot tethered, you need a camera and also your camera manufacturer's software that supports this function. By using the manufacturer's software you can download photos to a Watched Folder, as we discussed in Technique #16. Next, Lightroom can monitor and automatically import these photos as they are being captured.

First, install software from your camera manufacturer and modify the settings so the images are downloaded into a specific folder. For example, I have a Canon camera and use the Canon EOS Viewer, which downloads images to a folder called co_watched. Second, connect your camera to your computer via a USB port. Third, in Lightroom, enable Auto Import (see Technique #16) and specify the co_watched folder as the watched folder. Finally, begin shooting—and enjoy the experience of seeing large previews of your images quickly.

Canon EOS Viewer

Figure 17a A snapshot of a studio monitor, demonstrating how the Canon EOS Viewer and Lightroom appear together on the screen. The camera manufacturer's software is set to download the image into a specific watched folder.

Figure 17b Fashion photographer Tri Huynh photographs a model in the studio with his camera tethered to a nearby computer.

Note
When shooting tethered and using Auto Import in Lightroom, make sure to download the images to the main folder. Auto Import does not recognize and import images from a subfolder of a watched folder. In addition, be sure to turn off helper applications to prevent the camera manufacturer's software from automatically opening them.

Why Tethered?

One obvious reason is that it can help you catch problems early in the photographic process. If something does go wrong, the large previews you get when shooting tethered will alert you to the situation.

Another, less obvious benefit of shooting tethered happens when you're doing extended time-lapse photography. In this case, your memory card will not be big enough to store all of the images. Therefore, the best solution is to shoot directly to the hard drive.

Finally, a less-obvious reason for shooting tethered came to me recently when I was at a shoot with one of my colleagues. The setup was elaborate, and the budget was significant. As my colleague photographed the model, everyone on the set waited with anticipation for the image to appear on screen. When it did finally appear there was a collective sense of excitement. The whole shoot gained momentum. Of course, the opposite could have happened if things had gone wrong. Either way, if you haven't tried shooting tethered, I recommend experimenting with the process.

CHAPTER THREE

Library Module Overview

I'll never forget the time I visited a famous guitar maker at his workshop—the place was immaculate! All of his tools and supplies were organized and easy to access. It wasn't difficult to understand that the workshop directly enabled him to create beautiful and well-made guitars. And, how does a guitar maker's workshop relate to Lightroom?

For digital photographers, Lightroom is a workshop where we perform the art and craft of image postproduction. Due to a high volume of shooting, many digital photographers struggle to stay organized. As a result, their productivity, creativity, and enjoyment levels plummet. The good news is that the Lightroom Library module can help to organize, access, and filter your images in unique ways.

Whether you are an old pro or are new to Lightroom, this chapter will provide practical techniques for improving your photographic workflow. In particular, we will examine the interface, shortcuts, various view modes, navigation, toolbar, Filmstrip, and image rating and ranking.

#18 Understanding the Library Interface

The Library module interface looks a lot like the other Lightroom modules, but its functionality is unique. The panel, toolbar, and Filmstrip layouts are identical to the other modules. Beyond those basics, however, the Library module is quite different. In order to speed up your workflow, it's important to learn about the interface (this technique) and to learn the most common keyboard shortcuts (next technique).

The panels to the left of the interface contain the Navigator, Catalog, Folder, and Collections (**Figure 18a**). Use these panels to modify how you view and organize images. The panels on the right are the Histogram, Quick Develop, Keywording, Keyword List and Metadata (**Figure 18b**). Use the panels on the right to view the Histogram, to make simple developing changes, and to add or modify keywords and other metadata.

Figure 18a The left side panels in the Library module.

Figure 18b The right side panels in the Library module.

While the toolbar is present in each module, it is most similar in the Library and Develop modules. One of the main differences between the two modules is the unique capability of the Library module to view, compare, and organize images. You can also use the icons in the toolbar to tap into special functionalities of the Library module (**Figure 18c**). Only in the Library module can you view the images in Grid or Loupe, Compare or Survey the images, and finally, Sort the images by a wide range of criteria (**Figure 18d**).

Tip

Press the T key to toggle between hide and show in the toolbar for the current module.

Grid Loupe Compare Survey Sort order Sort

Figure 18c Use the toolbar to change how you view, compare, and organize the images.

✓ Capture Time
Added Order
Edit Time
Edit Count

Rating
Pick
Label Text
Label Color

File Name
File Extension
File Type
Aspect Ratio

User Order

Figure 18d In the Library module, sort your images based on any of these 13 criteria.

General Lightroom Interface Shortcuts

Because it is important to work quickly while in the Library module, don't forget to take advantage of the general Lightroom interface shortcuts we discussed previously.

Key Command	Function
F5	hide/show the Identity Plate and Module Picker
F6	hide/show the Filmstrip
F7	hide/show the left panel
F8	hide/show the right panel
Tab	hide/show the left/right panels
Shift + Tab	hide/show all the panels
T	hide/show the toolbar
L	hide/show the Filter bar

#19 Using Library Shortcuts

Each module responds to keyboard shortcuts that can help you increase your productivity. As a teacher, I'm aware that certain people like shortcuts about as much as they like going to the dentist. In the tables that follow, I will help you with the experience by highlighting the shortcuts that I find most helpful. As a starting point, try to circle or highlight at least three shortcuts to integrate into your workflow.

View shortcuts

Key Command	Function
F	Cycle through Full Screen modes
G	Grid View mode
E	Loupe View mode
C	Compare View mode
N	Survey View mode
L	Cycle through Lights Out modes
Control + Enter (Windows)	Enter Impromptu Slideshow mode
Command + Return (Mac)	Enter Quick Slideshow mode

Rating and flagging shortcuts

Key Command	Function
0–5	Set numeric rating
6–9	Set label rating
P	Flag as pick
U	Remove flag
X	Set as rejected

View Module-Specific Shortcuts Quickly

To view a list of module-specific shortcuts, first navigate to the module. For example, click on the Library module selector. Next, choose Help > Library Module Shortcuts. Now, here is a shortcut to view the shortcuts more quickly: Press Control + \ (Windows) or Command + \ (Mac) to open up the list of shortcuts for whatever module you are currently in.

Quick Collection shortcuts

Key Command	Function
B	Add to Quick Collection
Control (Windows) / Command (Mac) + B	Show Quick Collection
Control (Windows) / Command (Mac) + Shift + B	Clear Quick Collection

Photo shortcuts

Key Command	Function
Control (Windows) / Command (Mac) + E	Edit in Photoshop
Control (Windows) / Command (Mac) + R	Reveal in Explorer/Finder
Control (Windows) / Command (Mac) + Shift + C	Copy Develop Settings
Control (Windows) / Command (Mac) + Shift + V	Paste Develop Settings
Control (Windows) / Command (Mac) + []	Rotate image left or right
Control (Windows) / Command (Mac) + =	Zoom in
Control (Windows) / Command (Mac) + −	Zoom out
Control (Windows) / Command (Mac) + Shift + E	Export Image

#20 Using the Grid and Loupe View Modes

The Grid View and Loupe View modes are integral to the Library module. The Grid View mode allows you to see multiple image thumbnails at one time (**Figure 20a**). The Loupe View mode acts like a traditional photographic loupe, meaning that you can zoom into the grid—or you can just view one large image at a time (**Figure 20b**). The advantage of both of these view modes is that they enable you to quickly organize and process your images. Use these shortcuts to choose a view mode: G for Grid View and E for Loupe View.

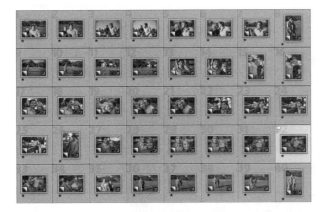

Figure 20a The Library module Grid View.

Figure 20b The Library module Loupe View.

In a typical photographic workflow, you begin by importing your images into Lightroom. Next, you look at the images in the Grid View mode and scroll through the images. This way it is possible to get an overall sense of the set of images. While this may seem like a simple step, it is incredibly important, as it provides a frame of reference for the more detailed steps of organization and editing that come later.

To scroll through the images you can use the scroll bar just to the right of the image thumbnails (**Figure 20c**). Based on your monitor resolution and viewing preference, be sure to change the size of the thumbnails by using the Thumbnails size slider in the toolbar (**Figure 20d**).

Scroll bar

Figure 20c Use the scroll bar to scroll through the thumbnails in the Library module Grid View.

Figure 20d Use the Thumbnails size slider to increase or decrease the size of the thumbnail images in the Library module Grid View.

#21 Grid View Options

Because the majority of your organizational work will take place in the Library module, it is worthwhile to learn a few more Grid View and Loupe View options to increase your speed and efficiency.

Let's begin with the Grid View, where you can make changes to specify other types of information that accompany the thumbnails. (We will cover the Loupe View Options in the next technique.) In order to access the controls to make changes, choose View > View Options or press Control + J (Windows) or Command + J (Mac) to open the Library View Options dialog (**Figure 21**). Click on the Grid View tab and select Show Grid Extras to view information and icons in the photo thumbnail cells. I don't recommend this in the Grid View; if you agree with me, you can deselect this option and show only the photo thumbnails, without any additional information.

Figure 21 Use the Library View Options dialog to customize the Grid Extras.

Next, choose Compact Cells or Expanded Cells. As the names imply, Compact allows you to show less information and smaller cells than Expanded, which displays the most photo information available in the Grid View. Once you make a selection you will see a live preview update in the Grid View.

Options

In the Options area of the dialog, I recommend that you select the following items:

- **Show clickable items on mouse over only.** By choosing this option, clickable items like flags or rotation buttons will appear when the cursor hovers over the thumbnails. This option gives you access to important features without adding more visual clutter to the Grid View.

- **Tint grid cells with label color.** By choosing this option, the thumbnail cell background will be tinted with the label color you have applied to the image. This option provides you with a nice, subtle way to view labels.

- **Show image info tooltips.** By choosing this option, tooltips for items (such as a flag rating) will appear when your hover the cursor over the item. Again, this allows you to access helpful information without adding more visual distractions to the Grid View.

Cell Icons

I recommend that you select Flags, Quick Collection Markers, and Thumbnail Badges, and deselect Unsaved Metadata in the Cell Icons area of the dialog. Here's what these icons do:

- **Flags** The Flag pick will appear in the upper left corner.

- **Quick Collection Markers** The Quick Collection marker will appear in the upper right corner.

- **Thumbnail Badges** These will show which photos have keywords, cropping applied, or image adjustments.

- **Unsaved Metadata** Deselect Unsaved Metadata unless you are going to add metadata with programs other than Lightroom, like Adobe Bridge. If you are going to use other programs, select this option so that an exclamation mark will appear to indicate that metadata has been saved to the file in an external application.

Compact Cell Extras

The Compact Cell view is a nice, clean, and simple view that you can customize to show only information that is most relevant to your workflow. Choose the following extras to add more information to the Compact Cell view:

- **Index Number** Shows the order number of the photo in the Grid View.

- **Rotation** Makes Rotation buttons available.

- **Top and Bottom labels** Show the top or bottom label you choose from the menu. Choose from more than 30 options, ranging from File Name to ISO to Camera Serial Number.

Expanded Cell Extras

The Expanded Cell view lets you see the thumbnails accompanied by as much information as possible. If you are going to use this option at all, you might as well select as many of the following options as are relevant to your workflow in order to add even more information to the Expanded Cell view:

- **Show Header with Labels** Shows the header area of the thumbnail cell, which can display up to four labels that you apply to the images. Choose from a wide array of label options from any of the drop-down menus.

- **Show Rating Footer** Shows the footer items you select. I recommend you select Include Color Label and Include Rotation Buttons, as this information and functionality can be helpful.

Grid View Shortcuts

- Press the J key to cycle through the view options.
- To open up the View Options dialog, press Control + J (Windows) or Command + J (Mac).
- To show/hide the Grid Extras, Shift + Control (Windows) or Command + H (Mac).

#22 Loupe View Options

The Loupe View allows you to view a single image at a time. To customize the view options for the Loupe View, choose View > View Options to open the dialog (**Figure 22a**). As you will notice, here there are fewer options than with the Grid View. This makes sense, as the Loupe View is intended to focus on a single image rather than a group of images.

To turn on the Loupe View options, select Show Info Overlay. Next, in Loupe Info 1 and 2, choose the information to be displayed. Choose from over 30 options here, ranging from File Name to Camera Serial Number, for each of the three fields. I recommend you deselect Show briefly when photo changes, as this information becomes distracting. Finally, unless your are a glutton for frustration, select Show message when loading or rendering photos. Otherwise, as a photo is loading or rendering you may be uncertain whether the file is unlinked or even whether your computer is functioning properly.

Figure 22a Use the Library View Options dialog to customize the Loupe View Info Overlay.

Custom Background Tip

Did you know that it is possible to customize the Loupe View background? The process is actually quite simple. While in the Loupe View, move your cursor over the background surrounding the image. Press Control + click to open a menu to change the background color or texture (**Figure 22b**).

Figure 22b To change the background color and texture, press Control + click on the background in the Loupe View.

Loupe View Shortcuts

- Press the I key to cycle through the Info Overlay options of none, Info 1, and Info 2.

- To open up the View Options dialog press Control + J (Windows) or Command + J (Mac).

- To show/hide the Info Overlay press Control + I (Windows) or Command + I (Mac).

#23 General Library Navigation

Knowing How to Navigate Counts!

The more familiar you become with navigating inside Lightroom, the better off you'll be as a photographer. One of my favorite nonacademic courses in college was Beginning Sailing. It was incredibly fun to cruise along the sunny California coast during the course. I learned from that experience that the best sailors know not only how to sail, but more important, how to navigate. In Lightroom the same is true. It's critical to learn how to quickly and effectively maneuver in Lightroom as well as how to use the program's full functionality.

In your own workflow, I recommend that after importing images into Lightroom, you navigate to the Library module to begin the task of editing. In the Library module, press the G key to choose to the Grid View. Next, scroll through the images to get an overview of the set of images. This gives you insight into the task at hand. Next, scroll back to the top of the set and click on the first image in the set.

Now that you are ready to begin to edit, double-click the image thumbnail (rather than pressing the E key) to navigate to the Loupe module. This will take the image to the Loupe View mode in a much more efficient manner.

While in the Loupe View mode, click the Navigator buttons to switch between the various zoom levels (**Figure 23a**). Choose Fit to zoom the image so that it fits in the preview area; choose Fill to zoom the image so that it fills your entire monitor; choose 1:1 to zoom to a 100% view of the actual pixels; or choose an option from the pop-up menu. You can also use the Zoom slider in the toolbar to change the zoom level (**Figure 23b**).

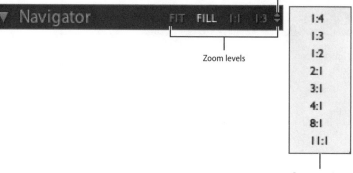

Figure 23a To switch between zoom levels click one of the options in the Navigator panel or choose an option from the pop-up menu.

Figure 23b The Zoom slider in the toolbar provides you with another method for zooming.

Once you have zoomed in, you can navigate around the image by using the Hand tool or the Navigator panel. When you zoom in to an image, the cursor automatically turns into the Hand tool. To use the Hand tool simply click and drag to reposition the area of the image that is revealed. Otherwise, when you zoom, the Navigator panel displays the entire image with a frame overlay to represent the zoom level of the main view (**Figure 23c**). To use the Navigator panel, click and drag the frame overlay to view the hidden areas of the image.

Frame overlay

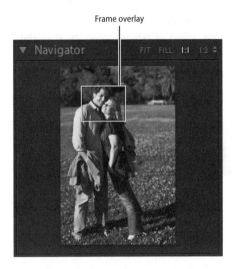

Figure 23c Use the frame overlay in the Navigator panel to view the hidden areas of the image.

Improve the Way You Zoom

When you zoom in to an image, it's sometimes tricky to select the area you want to see. To solve this problem, use the Zoom Clicked Point to Center option in the Interface tab in Preferences. This will zoom the area you click in the photo to the center of the screen.

#24 Adding Ratings and Labels in Library

There are many different approaches to adding ratings and labels. Some photographers use only a star rating, while others use stars, labels, and flags. Keep in mind that there is no one correct way to use these features. In fact, Lightroom was built to provide you with many options so that you can select one based on your own workflow needs. Whatever you choose, don't skip this step. It's essential to your Lightroom workflow.

While editing your photos in Library (see Technique #23 for navigating to Grid View and Loupe View after import), you will be adding a star, a flag, or label metadata to your images. The simplest way to add this information is to use the toolbar (**Figure 24a**). First, click on an image. Next, in the toolbar click the icons for stars, a flag, or labels to add the metadata (**Figure 24b**). To select another image, click it in the Filmstrip or press the right and left arrow keys. Then add another rating or label.

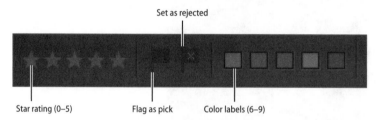

Figure 24a Add star, flag or label metadata to your images by clicking one of the icons in the toolbar.

Figure 24b When you add a star, flag or label rating, the icons in the toolbar will change appearance to indicate that the metadata has been added.

Metadata Shortcut Keys

Photographers typically take a large number of images, and clicking the icon in the toolbar can be time consuming. Here are a few shortcut keys that will speed up your workflow:

Key Command	Function
0–5	Add/Remove stars rating
6–9	Add/Remove label rating
P	flagged
U	Remove flag (or unflagged)
X	Set as rejected
[]	To decrease/increase rating
Control (Windows) or Command (Mac) + ⇑⇓	to increase/decrease flagging

Advanced Editing Shortcut Tip

Advanced Lightroom users can try out this navigating tip and edit even more quickly:

Press Caps Lock or press Shift + the rating or label (0-9, P, U, X).

This will add a rating or label, and it will automatically advance you to the next image. Of course, you can simply press a number and then use the arrow keys on your keyboard to move forward or backward through the images. But many photographers have found that the shortcut expedites the editing process.

#25 Utilizing the Toolbar

Toolbars are actually a relatively new invention, one that arrived with the advent of computer software and Web browsers. In generic terms, a toolbar is defined as a row or column of on-screen buttons used to activate functions in the application. Most toolbars are customizable, letting you add and delete buttons and functions. This is definitely true with the Lightroom toolbar, which is one of the most customizable aspects of the Lightroom interface.

You can find the toolbar (**Figure 25**) easily; it is above the Filmstrip and below the work area. To customize the toolbar, click the menu button. Next, select/deselect the items that you want to display. Be sure to note that the toolbar functionality is similar in all the modules, yet each toolbar is module-specific. Therefore, you can customize the toolbars for the different modules—for example, you can customize the Library module toolbar and the Develop module toolbar separately.

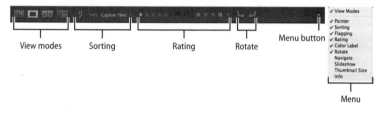

Figure 25 When you add a star, flag, or label rating, the icons in the toolbar will change in appearance to denote that the metadata has been added.

#26 Utilizing Survey and Compare in Library

In the days of traditional film photography, it was common to evaluate photographs by placing them on a light box. This analog process was actually intriguing and rewarding. In fact, I remember standing over a light box watching one of my photographic heroes edit his work. First, he grouped the photos based on similarity, theme, or some other criteria. Next, he began to work on the smaller groups of images, examining the details and making comparisons to determine which photo was best.

Overall, the process helped the photographer arrive at a group of well-edited images. Now, with the advent of Lightroom, there is a parallel process that can help you discover and define which of your photographs are best.

First, let's look at how we can "group" or survey images.

Survey

Press the G key to navigate to the Grid View. Select two or more photos. Or select two or more photos from the Filmstrip. Next, press the N key, choose View > Survey or click the Survey View icon in the toolbar (**Figure 26a**). This will open all of the images in a grid-based layout (**Figure 26b**).

Grid Loupe Compare Survey

Figure 26a In the Library module, the Compare and Survey icons are in the toolbar next to the Grid View and Loupe View icons.

Figure 26b It is often helpful to be able to navigate back and forth between the Compare and Survey Views. Utilize the Compare and Survey icons to change the view quickly.

To begin to work in the Survey View, click a photo in the work area or in the Filmstrip. In order to remove photos, click the Deselect Photo icon (the X) in the lower-right corner of a photo. You can also add rating or label metadata by clicking the rating and metadata icons below the photo (**Figure 26c**).

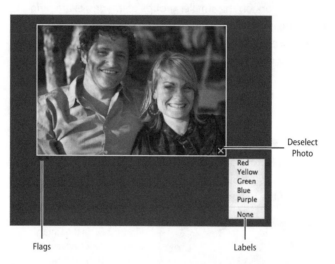

Deselect Photo

Red
Yellow
Green
Blue
Purple

None

Flags Labels

Figure 26c In the Survey View, click on the icons beneath an image to rate, label or remove the image from Survey View.

Compare

Press the G key to navigate to the Grid View. Select two photos from the Grid or from the Filmstrip. Next, press the C key, choose View > Compare or else click the Compare View icon in the toolbar (Figure 26a). This will open all of the images in a side-by-side comparison layout (**Figure 26d**).

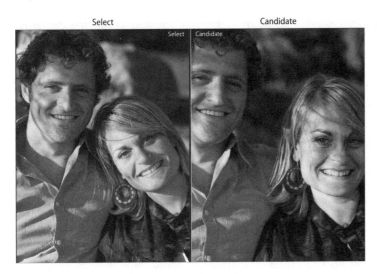

Figure 26d Use the Compare View to closely evaluate two images.

Although you have entered the Compare View, you can add ratings or label metadata here too, and you can also zoom in on the images. To add rating info, click the icons beneath the image (**Figure 26e**).

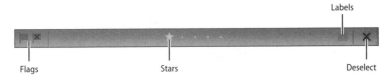

Figure 26e Add flag, star, or label ratings by clicking the icons beneath the photo.

Compare Mode Selections

The Compare View was built to compare at least two images. So what happens when you select only one photo and enter the Compare mode? Lightroom uses the currently selected photo and either the last photo selected or an adjacent photo in the Grid View or the Filmstrip.

Try using the icons in the toolbar for even more controls (**Figure 26f**). Let's first look at zooming in on the images in order to see more details. To zoom both images simultaneously, click on the Link Focus icon and then drag the Zoom slider. Or if you want to zoom in or out on just one photo, click on the Link Focus icon again and then drag the Zoom slider.

Figure 26f Click the icons in the toolbar to Link/Unlink Focus, to Zoom, to swap. Select and Candidate, to Make Select, and to Select the previous or next images.

To change the Select photo and the Candidate photo, follow the steps below:

1. In the toolbar, click Swap to reverse the Select and Candidate photos.

2. In the toolbar, click the Select Next Photo icon (or press the right arrow key) to compare subsequent photos with the first selection. Select Previous Photo to compare previous photos with the first selection. Press the up arrow to replace the Select photo with the current selection and replace the Candidate selection with the next image.

3. Click the Deselect Photo icon in the lower right corner below the photo.

4. Select the Candidate photo and then click the Make Select button in the toolbar.

5. Repeat steps 2 through 4 as needed to continually select and swap photos. When you are finished, click Done to exit the Compare View and change back to the Loupe View.

#27 Making Selections with the Filmstrip and Grid Views

When I first learned Photoshop, back in photography school, my teacher was found of the saying, "You must select before you correct." While selections in Lightroom are different than in Photoshop, the saying still holds true. In this technique, we will learn how to select images quickly.

Sometimes in Filmstrip and in the Grid View you need to select multiple images at one time; for example, when you want to compare or survey multiple images as described in Technique #26. In order to select multiple images in the Filmstrip or the Grid View, follow the steps below:

1. Click on an image in the Filmstrip or in Grid View.

2. To select contiguous images, press and hold the Shift key and click on another image (**Figure 27a**). The selected images will be highlighted.

3. To select noncontiguous images, press and hold Control (Windows) or Command (Mac) and click on other images (**Figure 27b**). The selected images will be highlighted.

Figure 27a An example of selected contiguous files in the Library module Grid View.

Adding Photos to Survey and Compare

You can always add more photos to your Survey View or Compare View. To do this, simply select the photos in the Filmstrip. Remember, though, that when you are in the Survey View, the more images you add, the smaller the previews will be.

Compare and Survey Selection Speed Tip

Technique #27 is especially helpful when using the Compare or Survey Views. To use the technique with the Compare View, select multiple images as described above. Next, press the C key. Finally, press the arrow keys to scroll and to compare the other images (from within the group of selected images) to the target image. To use this technique with the Survey View, select multiple images as described above. Next, press the N key. Then press the arrow keys to target a specific image from within the set of images.

Figure 27b An example of selected noncontiguous files in the Library module Grid View.

For those overachievers who really like keyboard shortcuts, try this one:

1. Click on an image in the Filmstrip or in the Grid View.

2. Press Shift + Right/Left Arrow to select multiple images.

3. Once you have finished making a selection and the selection is active, hold Command (Windows) or Control (Mac) and press the arrow keys to target one of the selected images.

Library Module Organization

For me, one of the best features of Lightroom is that it provides an effi-cient system to access and organize my images. Among various software options, Lightroom is my "top pick" because it was built specifically for digital photographers. Lightroom simplifies my postproduction process, taking the mystery out of the complex tasks of finding, filtering, organiz-ing, and storing images on one or more hard drives.

In this chapter you will spend some time learning how to organize and access your images in Lightroom. You will learn how to use Lightroom Catalogs, Folders, Collections, Filters, Image Sorting, and Renaming. These techniques will help you not only to become more organized, but also to be more creative as you find you have more time on your hands to make images.

#28 Understanding Catalogs

File Cabinets and the Catalog

To better understand catalogs, consider one of my photographic colleagues, who shoots with traditional film and organizes his enormous collection of negatives and slides in filing cabinets. He has an elaborate system for naming, labeling, and positioning thousands of his images. The Lightroom Catalog is the digital equivalent of his analog filing system, for without such a system, it would be impossible for the digital (or film) photographer to manage a large volume of images.

One of the main advantages of using Lightroom is that when you import your images they are added to a database, which is called a catalog. By having your images in a catalog you can find, preview, process, print, and showcase your work *quickly*.

The Lightroom Catalog is essentially a database file (**Figure 28**) containing image previews and information about the images. A catalog doesn't actually contain the image files, and this is advantageous because it provides you with added flexibility. For example, you can have one catalog that contains images located on multiple external hard drives. If the external drives are turned off you can still view the images and make metadata changes, add star ranking and color labels, add the images to Collections, and more.

File name and information
Metadata
Rating, Labels, Flags
Previews

Figure 28 The Lightroom Catalog file contains valuable information about your images. You can think of a catalog as a small, self-contained database for your images.

Even more, catalog information provides you with an immense amount of flexibility in managing, accessing, and processing your photos. For example, if you are traveling with a laptop computer, you can import photos into Lightroom and when you return to your home or studio, move the photos and catalog to your desktop computer or to other hard drives for backup. When you do this you can retain any changes and edits you have made while on the road.

Note
In Lightroom 1.0, the database information was referred to as libraries or library databases. Now, in Lightroom 2.0, the libraries have been improved and are called catalogs.

#29 Modifying Catalog Preferences

In the previous technique, we discussed the value of catalogs. Before you begin working in Lightroom, it is important to set up a Backup option in Catalog Settings that fits your needs. To open the dialog (**Figure 29a**), on a PC select Edit > Catalog Settings, and on a Mac select Lightroom > Catalog Settings. The General settings are divided into three sections: Information, Backup, and Optimize.

In the Information section you'll find details such as the location, file name, date created, last backup, last optimized, and file size. It is helpful to view this information so that you know a bit about the catalog you're using and about how recently it has been optimized and backed up.

Figure 29a The Last Backup and Last Optimized settings are the most important aspects of the Lightroom Catalog preferences.

In the backup section, click the pull-down menu to choose how frequently the catalog gets backed up (**Figure 29b**). Choose the option that best suits your needs, based on how often you use Lightroom and how important preserving your work is. The more regularly you use Lightroom and the more essential your work, the more frequently you will want to back up the catalog.

In the Optimize section you will find some information on ways to improve Lightroom performance. If you experience any program performance issues, navigate to this preference and choose Relaunch and Optimize.

```
  Never
  Once a month, upon starting Lightroom
✓ Once a week, upon starting Lightroom
  Once a day, upon starting Lightroom
  Every time Lightroom starts
  Next time Lightroom starts only
```

Figure 29b Choose a backup option that reflects your use of Lightroom.

#30 Using Catalogs

When you open Lightroom and import photos, a catalog file (Lightroom Catalog.lrcat) is created automatically. In most situations, it makes sense to use one catalog for all of your photos, but sometimes it may be advantageous to use more. For example, if you regularly shoot an incredibly high volume of photos you may find that Lightroom's performance slows as the catalog size increases. Or, let's say you're a professional race-car photographer. You may want one catalog for racing photos and another, separate catalog for your family photos. When working with multiple catalogs choose one of these options:

File > New Catalog—creates a new (and empty) catalog

File > Open Catalog—opens a preexisting catalog

File > Open Recent—shows a list of your recent catalogs

If you know that you are going to use multiple catalogs, navigate to your General Preferences to select which catalog is loaded when you start up Lightroom (**Figure 30a**). Choose Edit > Preferences > General (Windows) or Lightroom > Preferences > General (Mac) and change the default catalog to the option that best fits your workflow. By default, Load most recent catalog is selected. This option usually makes sense, but if you switch between catalogs frequently, choose Prompt me when starting Lightroom and you will be able to choose the catalog you want each time.

Figure 30a You can change the default catalog in Preferences under the General tab.

At other times, it may be advantageous to export images and the catalog file from your current catalog. For example, let's say that after a photo

shoot you have made the selection of ten final images. You are running short on time and want to give these images and the catalog information to an assistant to create and upload a Web gallery for the client to view. To export the selected images as a catalog, follow these steps:

1. Select the images in the Library Grid View or the Filmstrip.

2. Choose File > Export as Catalog.

This will open the Export dialog, where you can select a location for the exported files. You have a few more options to specify (**Figure 30b**). To limit the export to your selected images, choose Export selected photos only. In order to include a copy of the original image files, choose Export negative files. Finally, in order to speed up the preview for your assistant, choose Include available previews.

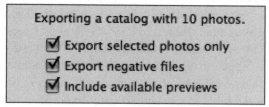

Figure 30b The options when exporting as Catalog.

#31 Using Folders

Folders can be used in order to manage, locate, and organize images. In fact, Lightroom Folders are a default feature of the program. When you import images into Lightroom you can choose either to leave images in their current location or to move them. Either way, Lightroom takes notes of where the images are and remembers the hard drive and folder location for them.

Navigate to the Library module and open or expand the Folders panel. Here you will find the titles of the hard drives from which you have imported images into Lightroom. In the screen grab below you will notice that I have images on two hard drives, "el jefe," the internal drive on my laptop, and "sashimi," an external drive (**Figure 31a**). The status light to the left of the hard drive name will change based on the drive's connectivity. If the drive is disconnected, the light will go off. If the light turns yellow, it serves as a warning that you are low on disk space. If the light turns red, then the drive is almost out of disk space. If the drive is connected, the light will be green.

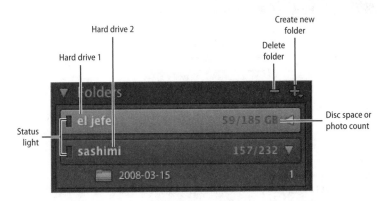

Figure 31a Most photographers eventually need to store images on multiple drives. The Lightroom interface not only reveals which drive the images are stored on, it can reveal valuable information about the drive or about the images themselves.

To open the hard drive folder, click anywhere in the rectangular space where the name of the hard drive is displayed. In the screen grab above I have opened the folder for the drive "sashimi." Beneath the name of the hard drive you can see which images have been imported into Lightroom. The sashimi display shows that I have imported one image from this drive, and that it is in the folder 2008-03-15.

Renaming Images

While you are working with a group of images in Folders (or any other view in Library module), you can rename the images with ease. Select the image(s) you wish to rename. Choose Library > Rename Photos or press the shortcut key F2. Choose new name in the rename dialog.

As you begin to work with folders you will discover a number of ways to modify them and their contents. For starters, you can double-click the folder name to rename the folder. You can drag images into new folders by simply clicking and dragging, but note that when you do that the move dialog will ask you to confirm the relocation of an image. To confirm the change, press the move button. To add or delete folders click the minus and plus icons in the top right corner of the Folders panel (**Figure 31b**). When you click the plus icon it opens a dialog where you can name the folder, place it inside of another folder, and select images to include in that folder.

Click the plus icon and choose the option to open the folder dialog shown below

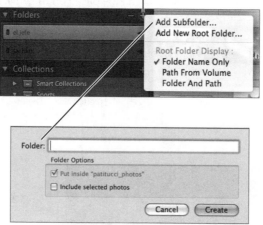

Figure 31b Click the plus icon to choose between Add Subfolder or Add New Root Folder. A subfolder is automatically added inside of the currently selected folder. A new root folder is a separate root-level folder. In addition, you can click the plus icon to change how the folder appears in the Folders panel. By default only the folder name is displayed, but you can choose to display only the path from the volume or both the folder name and the volume path.

Tip

In the Folders panel, right-click (or Control-click on Mac) to the right of the name of the hard drive to change the display. Choose disk space, photo count, status, or none.

#32 Using Collections

Both collections and folders allow you to view a specific group of images, but each feature is distinct. Collections can be viewed, utilized, or modified in every module except the Develop module. Folders can only be viewed in the Library module. Another difference between collections and folders is that folders contain images that are located in one place, while collections can contain a set of images from multiple folders. In other words, collections allow you to group, view, and access images in a way that is not dependent on the traditional folder structure.

In this tip, I want to cover three types of collections: Collections, Smart Collections, and Quick Collections. All three can be used in different ways to create groups or sets of images, based on specific criteria.

Collections

To create a normal collection, you can select multiple images in the Filmstrip or in the Library Grid view, or simply create a collection without selecting images. Either way, the next step is to click the plus icon in the Collections panel (**Figure 32a**) and choose Create Collection. This will

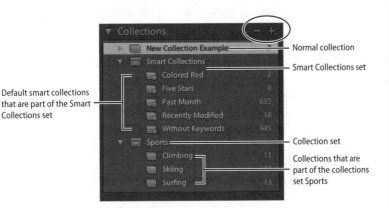

Figure 32a The Collections panel as viewed in the Library module.

Optimize How You Work With Collections

One of the quickest ways to add an image to a collection is to click on one or more images and drag them to the name of the collection. Or you can click and drag the name of the collection and drop it onto the images. Finally, if you like to use shortcuts, in the Library module you can press Control + N (Windows) or Command + N (Mac) to create a new collection. In the New Collection dialog you can then choose to add currently selected images to the new collection.

Understanding Catalogs, Folders, and Collections

The concepts of catalogs, folders, and collections can be a bit confusing. To better understand, try viewing a catalog as a house and the folders as the rooms within the house. While they are related, still both are distinct. Next, a collection might be seen as a group of posters that you place throughout the rooms of the house. Thus, while the poster collection is located within the house, it is independent of the rooms within that house; that is, a collection can be a unified set of objects that are not limited by any other organizing structure. Catalogs, Folders, and Collections are interrelated, yet at the same time, all three are separate entities.

Figure 32b Use the Create Collection dialog to define the collection.

open the Create Collection dialog (**Figure 32b**), where you can define a collection name, include the collection in a set, Include selected photos (if you have selected photos), and Make new virtual copies of the photos for the Collection.

While normal collections are created by selectively adding images, smart collections are based on specific criteria or rules. By default, Lightroom is equipped with a set of predefined smart collections, as shown in **Figure 32c**. Of course, you can also create your own.

Smart Collections

To create a Smart Collection, when you click the plus icon shown in Figure 32a, choose Create Smart Collection to open a dialog (Figure 32c). Use this dialog to name the smart collection, to include the smart collection in a

Figure 32c Use Create Smart Collection to define rules specific to a particular smart collection.

collection set, and to define specific rules for the smart collection. You can add or delete rules by clicking the plus or minus icons next to the rules. Next, click on the pull-down menus to change the criteria for the rules.

Quick Collections

The advantage of Quick Collections is speed; it allows you to quickly group images together. You can save a quick collection to a collection by right-clicking and choosing Save Quick Collection. Also, if you want to save a particular group of images, you can turn it into a normal Collection, as described above.

To add images to a quick collection, navigate to the Library module. Next, select one or more images and press B or drag the selected image(s) to the Quick Collection option in the Catalog panel (**Figure 32d**). Once an image has been added to a quick collection, press B again to remove it. To view the images in the quick collection, press Control + B (Windows) or Command + B (Mac).

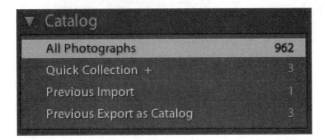

Figure 32d Quick Collections lets you select and view a group of images quickly.

#33 Finding Images with Text, Refine, and Metadata Filters

Filter Shortcut Highlights

Once you learn these few filter shortcuts, you will be using them all the time:

1. Control (Windows) / Command (Mac) + F = Filter Text and Highlight the text field

2. Press the \ key to toggle between hide / show the filter menu

3. Press Shift + click + Filter Menu Names (Text, Refine, Metadata) to show multiple filter menus at one time. This is the only way to show all three filter menus at once!

On a recent California backpacking trip in the Sierra, I ran out of water, so I needed to use a special water filter to remove the impurities of the stream water. Water filters typically remove unwanted stuff, and this is also exactly what a filter does in Lightroom. In digital photographic context, knowing how to edit or filter your images is paramount.

The filter bar is in an easy-to-access location, right above the thumbnails in the Library Grid module. There are three types of filters: Text, Attribute, and Metadata. There is no one filter that works best, as each filter performs a different task. At times, one filter by itself will lead to the best results. Other times a combination of filters results in the most useful searches. To open one of the filters, click on the filter buttons to the right of the Filter, and the filter menus will appear below (**Figure 33a**).

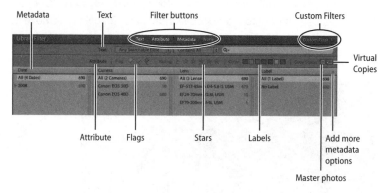

Figure 33a Click the filter buttons to reveal the filter menus.

The Text filter allows you to type in search word(s) and then define the search parameters from those words. There are three ways to define the parameters:

1. Click Any Searchable Field and choose from a list of options.

2. Click Contains All and choose from a list of options.

3. Check the drop-down menus in the Text field to choose from the entire list of options (**Figure 33b**).

Sorting—Another Way to Filter

In our house, folding laundry isn't just about folding; it is about sorting and folding. I fold and create a pile of towels, a pile of my wife's clothes, my daughter's clothes, etc. Sorting allows me to group the items in a useful way. And Lightroom has a similarly strong sorting feature that you can access by way of the toolbar. In the toolbar click on the option to the right of the word "Sort" to choose one of the following options: Capture Time, Added Order, Edit Time, Edit Count, Rating, Pick, Label Text, Label Color, File Name, Extension, File Type, Aspect Ratio, or User Order (i.e., custom order). Next, click the A-Z icon to the left of Sort to reverse the sort order.

```
√  Any Searchable Field
   Filename
   Copy Name
   Title
   Caption
   Keywords
   Searchable Metadata
   Searchable IPTC
   Searchable EXIF
   Any Searchable Plug-in Field

   Contains
√  Contains All
   Doesn't Contain
   Starts With
   Ends With
```

Figure 33b Limit or define your text search with these options.

The Attribute filter allows you to show images based on Flag, Star rating, Color Label, Master Photos or Virtual Copies. Click a single option or multiple options to fine-tune your search.

The Metadata filter provides you with the most in-depth options. There are four customizable default general criteria columns—Date, Camera, Lens, and Label. To filter based on metadata, simply click on the metadata field. For example, to filter based on a specific lens, click on the type of

Text Filtering Tip

Here's a tip I learned from Lightroom expert Sean McCormack. When using the Text Filter you can further refine your search by excluding images containing certain word(s). To do this, put ! before the word. For example, typing !food will exclude images with the word "food" in the file information.

lens in the Lens column. Now you will only see images photographed with that lens. You can also select criteria from multiple columns to limit your filtering even further. In addition, you can click on the column title to access more than 20 metadata options (**Figure 33c**). For more, click the plus sign icon in the far right column to add up to four additional metadata columns.

Date
Date (Hierarchical)
File Type

Keyword
Label

✓ Camera
Camera Serial Number
Lens
Flash State
Shutter Speed
Aperture
ISO Speed
GPS Data

Location
City
State / Province
Country

Creator
Copyright Status
Job

Aspect Ratio
Treatment
Develop Preset

None

Figure 33c Change a Metadata column by clicking the title and choosing one of these options.

Tip

If you find yourself using the filters often, try the Custom Filter option. It is at the top and to the far right of the Filter area. Click the button to choose a range of custom filters, or choose Save setting as a new Custom Filter to create your own filter for frequently used search criteria.

Library Module— Quick Develop

In the days when analog film ruled the roost, you could find one-hour photofinishing services practically anywhere. Their value was the ability to quickly process and print your images. In this chapter, we discuss a much quicker way to process your photos: in Lightroom, with Quick Develop.

Before we dive into Quick Develop, it is helpful to take note of what we have covered so far. Up to this point, we have focused on the aspects of the Library module that help you increase the speed and effectiveness of your image rating, organization, and file management. But there is much more. The Library module can help streamline how you process and develop your images. In particular, you can use Quick Develop to make both simple and complex image corrections to a single image or to a group of selected images. You can make these changes without leaving the Library module.

Quick Develop is intuitive and easy to use. As a result, this chapter will be simple and brief, too. First, we will examine how to use the presets to supercharge your image-processing workflow. Next, we will look at how to correct white balance. Finally, we will examine how to make more general tonal corrections and enhancements.

#34 Using Presets

The Lightroom presets provide you with the ability to be prepared for anything and to apply settings to your images at a moment's notice. In the Library module there are three types of presets: Saved Preset (Develop setting), Crop Ratio, and Treatment (**Figure 34**).

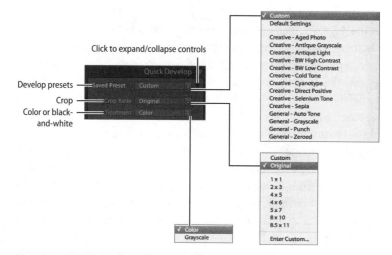

Figure 34 Speed up your workflow in the Library module by taking advantage of the default presets that come pre-installed with Lightroom.

Saved Preset

The Saved Preset is one of the most useful presets, as it allows you to access your Develop setting presets. These can also be created, modified, deleted, and accessed in the Develop module Preset panel, located on the left of the interface (Figure 34). Here you can take advantage of the full power of the Develop module Develop settings simply with the click of a button. Plus, as you spend more time working in Lightroom, you can create other presets that will work best with your particular workflow.

Crop Ratio

The Crop Ratio preset automatically crops your images to a specific aspect ratio. The downside of this feature is that you have no control over what is cropped; still, it can provide you with a quick preview of a particular crop ratio without your having to leave the Library module. This feature works best when you combine it with the Develop module.

For example, make a selection of multiple images in the Filmstrip. Next, in the Quick Develop panel choose a crop ratio. This will apply the crop ratio to the entire group of selected images. To modify the crop so that the composition works best with each image, press the R key to go to the Crop tool in the Develop module. Modify the crop. Select the next image, modify the crop, and continue. This is the quickest way to successfully change the crop ratio of a group of images.

Note
When using the Crop tool, you can press return or enter to accept the crop. After you do this you will need to press R again on the next image to reselect the Crop tool. If you would like to keep the Crop tool active, follow this technique: Press Control (Windows) or Command (Mac) + the arrow keys to navigate to the next/previous image while keeping the crop active.

Treatment

The Treatment preset gives you the ability to apply a color or grayscale (black-and-white) treatment to your image. The grayscale conversion is based on color temperature and tint values; therefore, you can make changes to Color Temperature and Tint in order to further modify the grayscale image.

Tip
Rather than using the Treatment preference preset, press the V key to quickly toggle the image between color and grayscale versions.

#35 Correcting White Balance

Correcting White Balance for Multiple Images

If you have multiple images to color correct, select them in the Filmstrip or the Library Grid View. Next, navigate to the Library Loupe View. In Quick Develop, choose a new white balance option to change all of the selected images. Or use the temperature and tint controls, which will apply a relative change to each individual image rather than making all the images uniform.

Color can be compelling, engaging, endearing, or shocking. Color has the power to convey emotion, to convince, to remind, and to illuminate. For the photographer, learning how to work with color is paramount. In the Library module, use the Quick Develop White Balance panel (**Figure 35**) to streamline the color corrections and enhancements of your images.

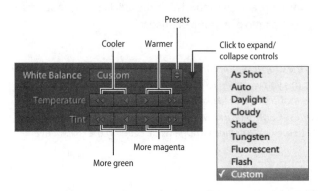

Figure 35 Use the White Balance panel to quickly make critical color corrections and enhancements to raw files. For JPEGs, only As Shot, Auto, and Custom are available as white balance presets.

Before we talk about how to create "correct" color, it is worth mentioning the general subject of color balance. In digital photography, color balance has to do with correcting images based on color temperature. Because different color temperatures create different colors, you can run into certain problems.

To learn how to use the white balance controls in Lightroom, let's consider a specific photographic scenario. For the sake of this discussion, say that you photographed a person wearing a white T-shirt who was standing in the shadow of a building. Your hope was to create a warm portrait. Upon opening the image in Lightroom, you discover that that white T-shirt is blue; in fact the entire image has a blue cast. Don't worry—you haven't made a mistake. This cast is the result of the cool color temperature of shaded areas.

To fix the color, click on the white balance menu and choose Shade. The white T-shirt will now appear white and correct. To finish off the image, click one of the right-side temperature arrows to increase the overall image warmth.

The Temperature and Tint arrow buttons allow you to increase an effect incrementally. Use the single arrow to add a smaller incremental change; use the double arrow to add a larger one.

With the White Balance menu you can choose a color temperature preset to try to match and fix the light color for your images. Use the Temperature arrow buttons to cool (add more blue) or to warm (add more yellow) the image. Use the Tint arrow buttons to add more green or more magenta.

Learning to See Color

One of the most wonderful aspects of photography is that it teaches you to see both the color of your photographic subject and the color of the light on and around your subject. As you begin to see color you will discover that natural and created light sources can have a wide range of color temperatures. For example, the light from the sun can be sunset yellow and warm, or midday bright and white, or evening cool and blue.

As photographers, we need to be trained to see these colors. Typically, color shifts go unnoticed because the human eye is incredibly sophisticated and adaptable. Consider what happens when you put on a pair of sunglasses with yellow lenses. At first everything appears to be tinted yellow. Yet, after a few minutes colors look normal. So it is helpful to learn about color temperature in order to wake up your senses to its presence. This will help you create more compelling photographs.

#36 Modifying Tone and Color

While the Library and Develop panels are each distinct, they do share many of the same options for modifying tone and color. In particular, in the Library Quick Develop panel you can access all of the same controls as in the Develop panel for changing Exposure, Temperature, Tint, and more (**Figure 36**). However, the two sets of controls work differently. Unlike controls in the Develop module, the Library Quick Develop controls work incrementally, making them best for instituting relative or minor changes. Use the single arrows for making smaller incremental changes and the double arrows for larger adjustments.

Advanced Shortcut to Sharpening and Saturation

In Quick Develop, you will not find controls to change sharpness and saturation, yet believe it or not, this can be done with a shortcut. Press and hold Alt (Windows) or Option (Mac). The Clarity control will turn into Sharpness and the Vibrance control will turn into Saturation. Next, press the arrow keys to make the respective changes.

The Advantage of Relative Adjustments

The Quick Develop controls are relative, in contrast to the Develop module controls, which are absolute. This means that in Quick Develop if you select and modify two images, the changes will build on the existing characteristics of both. If you take one image with an exposure of 0 and one with an exposure of +1 and then click the icon to increase exposure, the first image's exposure setting will become +1 and the second image's +2. In contrast, doing this in the Develop module will result in both images having an exposure setting of +1.

Click to expand/collapse controls — Auto

Press Alt (Windows) or Option (Mac) to change to Saturation

Press Alt (Windows) or Option (Mac) to change to Sharpness

Figure 36 Use the Quick Develop Tone and Color controls to make the same kinds of changes to your images as you can make in the Develop module

For a real quick fix, press Auto Tone to adjust the tone automatically in your photos. When you press this button, Lightroom will analyze and adjust your image so that there is adequate detail in the highlights and shadows. While Auto Tone may not give you the best final results, it can "normalize" your image so that it becomes a strong starting point to build from. Next, click the controls to adjust the photo's white balance, color saturation, and tonal scale.

Tip

While in Quick Develop, you can click the name of a control to reset that control to zero.

Library Module—Metadata

In digital photography circles these days you'll hear people talk about metadata about as frequently as arborists talk about trees. The reason metadata is so important is that it allows photographers to access and add vital information about images. In the simplest terms, metadata is data about data. In photography, the photo is considered the main data, and the metadata refers to everything else, from the labels and keywords to the details of the camera settings, including which lens, focal length, and aperture were used to make the photo. One way to think of photographic metadata is to divide it into two main types. One is metadata that can be added or customized; the other is metadata that is informational and unchangeable. In this chapter, we will learn how to customize the first type and how to take advantage of the second.

We will start by learning how to add metadata keywords to our images, looking first at multiple ways to add keywords and then at how to create and use keyword sets to speed up the keywording workflow. Next, we will examine how to modify and synchronize metadata across multiple images. Finally, we will explore how to use metadata presets to save time and to make your keywording process much more enjoyable.

#37 Adding Keywords

Adding keywords will help you sort and find specific images quickly, but doing it is tedious and time consuming, so many of us don't bother. Here's the good news: Lightroom will take much of the pain out of the process, and you might actually enjoy it and appreciate the benefits.

To add keywords to your photos, navigate to the Library module and select one of the options below. Choose the option(s) that work best for you.

Keyword Tags

In the Library module, open the Keywording panel (**Figure 37a**). If you have already added keywords to the image, you will see the list of keywords in the Keywords Tags area. To add keywords, double-click in the Enter Keywords box and start typing. Or click in the area that reads Click here to add keywords and type the keywords, separating words with a single comma. After you add them this way, the keywords will appear in the panel above in alphabetical order.

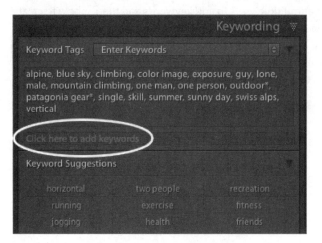

Figure 37a Utilize the Keyword Tags and Keyword Suggestions panels to add to and manage your image keywords.

Keyword Suggestions

Another way to add keywords is to use the Keyword Suggestions panel (see **Figure 37a**, above). Here Lightroom will suggest keywords based on a few variables, including the other keywords and the time the image was

How Important Is Keywording?

I want to tell you a true story that illustrates just how important keywording is. I respect and admire Julieanne Kost, a talented photographer, thinker, communicator, and also a Photoshop and Lightroom Evangelist for Adobe. Recently, she took a long-overdue sabbatical. One of her main tasks during her sabbatical was keywording her entire image archive in Lightroom. Now, if keywording is important enough for Kost to do on her sabbatical, it is important enough for you to do in your daily workflow. Even if you don't have the time to keyword your image archive, start keywording your recent work and you won't get backlogged. Remember, the photo you can't find is a worthless photo.

captured. In this way, Lightroom works hard to "learn" how you keyword. To add a keyword suggestions word, just single-click that word.

Keyword List

Open the Keyword List panel (**Figure 37b**), located beneath the Keywording panel, and you will discover all of the keywords in your keyword library. Click on an image, and a check mark will appear next to the keyword already applied to the image. To add more keywords using this list, simply click on one or more images in the Grid View and drag the image selection onto a keyword. Or click on one or more of the keywords in the list and drag the selected words onto the image.

More Ways to Add Keywords

Another excellent way to add keywords to your images is to use a keyword set. To learn more about how to use keyword sets, see Technique #38.

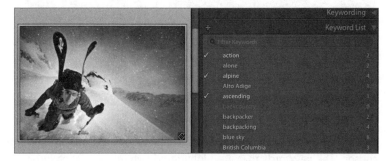

Figure 37b Use the Keyword List to add new keywords and modify previously added keywords.

Tip
Press Control + 2 (Windows) or Command + 2 (Mac) to toggle open/close the Keywording panel. Press Control + 3 (Windows) or Command + 3 (Mac) to toggle open/close the Keyword List.

#38 Using Keyword Sets

Keyword sets let you create and then easily access keywords that you need to use frequently. Without keyword sets you would have to scroll through your whole list of keywords every time you wanted to use one. Think of keyword sets as the quickest way to add nine of your top keywords. Navigate to the Library module Grid View. Open the Keyword Set panel (**Figure 38a**). Click on the pull-down menu to the right of the Keyword Set title and choose among a range of options: recent keywords, previously defined sets of keywords, choose Save Current settings as a new preset, or edit set.

Click here to open Keyword Set options

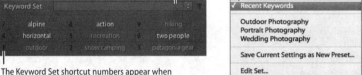

The Keyword Set shortcut numbers appear when you press Alt (Windows) or Option (Mac)

Figure 38a The Keyword Set panel allows you to create, edit, and use sets of keywords, which can be grouped in various ways.

In the example pictured above, the Recent Keywords option has been chosen. The keywords that are highlighted (white) have already been added to the image, while the keywords that are muted (gray) have not been added. Click on the highlighted white keywords to remove them, and click on the gray keywords to add them to the image.

To create a custom keyword set, click on the pull-down menu and choose Edit Set. This will open the Edit Keyword Set dialog (**Figure 38b**). Next, type in new keywords in the Keywords fields. Finally, click on the Preset pull-down menu and choose Save Current Settings as New Preset.

Click here to view the Preset options

Figure 38b To speed up your workflow, create various custom sets of keywords that match the type of photography you do.

Library Module—Metadata

#39 Working with Metadata

Metadata is a broad term that refers to a wide range of information. The one place where you can access all of the metadata is in the Metadata panel, which is in the Library module (**Figure 39**). For starters, there is a wealth of information associated with each image. The sheer amount of information can be a bit cumbersome. But keep in mind that the Metadata panel isn't just there for show; rather, it has been designed to help you access and use this information with ease.

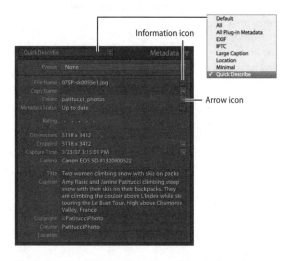

Figure 39 If you are new to working with metadata, choose the Quick Describe option from the pull-down menu to view some of the more important metadata fields.

To work with metadata, open the panel and then choose one of the nine options from the top pull-down menu. In the example shown in Figure 39, Quick Describe has been chosen. This option provides a condensed view of some of the more important metadata.

At first glance, it may seem that all of this information is inert and simply descriptive, but in fact the Metadata panel is very much alive. And two of the icons in the panel enable you to use or change the metadata in specific ways.

First, think of the arrow icon as the "go to" icon. For example, you would click the arrow to the right of the folder patitucci_photo to go straight to that folder. Second, think of the information icon as the "make changes"

Metadata and Your Web Site

You can use metadata to drive clients to your Web site. To take advantage of this feature, choose All from the metadata pull-down menu at the top of the Metadata panel. Scroll down to the Contact section. In the Web site field type in the full URL for your Web site (for example: http://www.patitucciphoto.com). Now when you export the image, it will contain this metadata field. When someone imports the image into Lightroom, they can click the arrow icon to the right of the Web site URL, and it will launch their Web browser and open up your site.

icon. For example, you would click the information icon to the right of the File field to activate the option of renaming the image.

Note
Two of my all-time favorite photographers are outdoor adventure-sport photographers Dan and Janine Patitucci. They do high-profile commercial work and run an extremely successful stock agency. Because metadata is integral to their workflow, I thought it would be interesting to showcase it—so the metadata examples that you see in this technique were taken from one of their images.

#40 Using Metadata Presets

Metadata presets and synchronizing metadata have much in common. In the next two techniques we will cover both topics, starting with presets.

While you are using Lightroom, if you ever need to apply similar metadata to more than one image, you will want to create a metadata preset. Even if you don't apply much metadata, you will at least need to add your copyright information to all of your images.

Metadata presets allow you to create a set of metadata variables that you can them apply to other images upon import (see Technique #15) or while you are working in the Library module. In the Library module, open the Metadata panel and click on the Preset pull-down menu (**Figure 40a**).

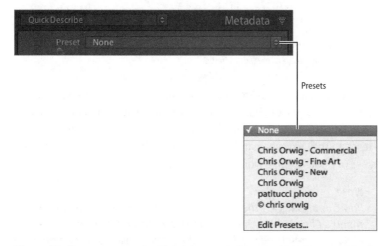

Figure 40a You can access the Metadata presets from the Metadata panel in the Library module.

In this menu, you can access any presets that you have previously created or you can choose to edit a preset. Choose Edit Presets to open the edit dialog (**Figure 40b**).

Figure 40b Edit Metadata Presets allows you to create new presets based on a wide range of metadata fields.

In the Edit Metadata Presets dialog you can choose a previously cre-ated preset or make changes to the various fields—adding copyright information, for example. Finally, choose Save Current Setting as new Preset. In this way, you can build up presets that apply to different your types of photographic work.

Note
You can also access the presets from the main Lightroom pull-down menus. Choose Metadata > Edit Metadata Presets to open the Edit Metadata Presets dialog. Next, in the dialog make a selection from the Presets pull-down menu.

#**41** Synchronizing Metadata

The images in your photo library will have unique metadata and also shared metadata. Therefore, it's a good idea to synchronize or copy metadata from one image to another and take advantage of metadata presets.

To use Synchronize Metadata, select an image and make a metadata change. For example, apply a metadata preset as described in Technique #40. Next, press Control (Windows) or Command (Mac) and click on one or more images in the Library module Grid View. Then choose Metadata > Sync Metadata or click the Sync Metadata button (**Figure 41a**), located below the Library module right-side panels, to open the Synchronize Metadata dialog (**Figure 41b**). Before you commit to synchronizing the metadata, make any needed changes in this dialog. When you are finished, click the Sync Metadata button.

Figure 41a Use the Sync Metadata button when you need to apply similar metadata to multiple images.

After modifying the metadata, click the Synchronize button to synchronize

Synchronize Shortcut

When you click the Sync Metadata button it opens the Synchronize Metadata dialog. Viewing the dialog is helpful when you need to make specific changes before you synchronize the information. But if you are confident that you won't make any further changes, press Alt (Windows) or Option (Mac) and click the sync button to skip opening up the dialog. If you need to synchronize settings often, this simple shortcut will save you quite a bit of time.

Figure 41b A quick comparison will reveal that the Synchronize Metadata dialog is practically identical to the Edit Metadata Presets dialog. As the similarity suggests, the two dialogs are related, but it is best to first create presets and then take advantage of those presets with the synchronize feature.

CHAPTER SEVEN

Library Module— Edit and Export

Recently one of my photography students asked for feedback on a set of images taken on a ski trip to Antarctica. The trip was organized to capture still and video footage for an upcoming Warren Miller ski film. The skiers and scenery were amazing. He asked what he could do to make the images even stronger. My response was simple: "Use Photoshop and send them off!"

My student had already enthusiastically adopted Lightroom and made it his main work-processing tool. In his excitement he'd forgotten that Lightroom works well as a stand-alone application, but even better with Adobe Photoshop. Spending just a few minutes in Photoshop would make his images that much better. The good news is that he took my advice, and the set of photos turned out stunning.

In this chapter we explore exporting our work out of Lightroom and editing the images in Photoshop. By shifting our focus to "leaving" Lightroom, we'll deepen our postproduction skills and ultimately make better photographs.

#42 Exporting Images from Lightroom

New Export Option

New to Lightroom is the much-requested ability to export to the same folder or even a subfolder of the current folder. In this way you are now able to keep your files organized in their original location.

There are many reasons to export your images from Lightroom: to email JPEG images to clients or to send them high resolution files—and there is always the need to back up images on a CD or DVD.

To export images from Lightroom select one or more images in the Library module Grid View or in the Filmstrip at the bottom of the Lightroom interface. Next, choose File > Export, or press Shift + Control (Windows) or Command + E (Mac). This will open the Export dialog (**Figure 42a**). You can either choose one of the presets on the left (these will be discussed in Technique #43) or customize your export options using the menu on the right.

Figure 42a There is a wide range of options to control everything from the file name to the file color space when exporting images from Lightroom.

Let's take a look at a few of the Export menu options. First, opt to export Files on Disk or Files on CD/DVD. To choose between these two options click in either the area that reads Files on Disk or the one that reads Files on CD/DVD. (**Figure 42b**).

Figure 42b Select Export to Files on Disk to export images to a specific folder. Choose Export to Files on CD/DVD to automatically export and burn files to a CD or DVD.

Next, refine the export settings by expanding the various panels (**Figure 42c**). Here are some highlights of those settings:

- Use the Export Location panel to choose a destination folder. If you need to keep track of the images check Add to This Catalog.

- Select the File Naming panel for a naming convention Template or Custom Text.

- Select the File Settings panel to choose from the file formats PSD, TIF, JPEG, DNG, and Original.

- Open the Image Sizing panel for a resizing option that best suits your workflow. Select Don't Enlarge and instead use Photoshop to resize the image so that you can see your results immediately. Or select Enlarge so that Lightroom resizes the image. The downside of using Lightroom is that you can't immediately see the results, but the advantage is that Lightroom uses an interpolation method considered superior to Photoshop's method.

- Choose Output Sharpening for Screen or Matte or Glossy paper, and from the Amount drop-down menu choose Low, Medium, or High.

- Click the Metadata panel and choose from Minimize Embedded Metadata, Write Keywords as Lightroom Hierarchy (if someone else will import the image into Lightroom) and—if the copyright is critical—Add Copyright Watermark.

- Open the Post-Processing panel and select what should be done after the image has been exported.

Figure 42c Open and close the different export settings panels by clicking on each panel title bar.

Exporting Raw Files

I am often asked, "How can I export the original raw file?" The answer is to select Original from the File Settings Format menu. This way you can export the original file so that you end up with two full, identical versions of the image.

Export Panel Navigation

The Export panels work exactly the same way as the module panels. By default you are able to open all of the panels at once and use the scroll bar to view panel details. For expert navigation, select Alt-Click (Windows) or Option-Click (Mac) to change the panel title. This will change the panels to Solo mode, in which only one panel is open at a time. If you click on another panel, the panel that is open will close, and the clicked-on panel will open.

#43 Exporting and Presets

Ready! Preset! Go! The more you use Lightroom, the more you will discover that presets enhance and optimize your workflow in subtle yet significant ways.

To export with presets choose File > Export with Preset and select the appropriate preset, or choose File > Export to open the Export dialog. From there you can choose a preset (**Figure 43a**). As you can see, the File pull-down menu will display all of the default Lightroom Presets as well as any custom User Presets you have created.

File menu

Export dialog

Figure 43a The same Export Presets can be accessed through the File pull-down menu or in the Export dialog. The advantage of using the File pull-down menu is speed. The advantage of using the Export dialog is being able to choose a preset and make further changes in the Export panels.

To create your own presets choose File > Export to open the Export dialog. Next, modify the settings in the various panels, as described in Technique #42. Once you have finalized the settings, click the Add button.

(**Figure 43b**) to open the New Preset dialog (**Figure 43c**). Type in a name for the preset and then click on the pull-down menu to assign the preset to the current folder or to select a different folder.

Figure 43b Quickly create a custom export preset from inside the Export dialog.

Figure 43c Name and organize your presets with the New Preset dialog.

Recycling Export Settings

In Lightroom you can speed up your workflow by recycling or reusing export settings. While this won't really help the environment, maybe it will help you work faster and use less electricity. (Okay, I know that's a bit far fetched.) To reuse an export setting, select one or more images from the Library module Grid View or from the Filmstrip. Next, choose Shift + Alt + Control + E (Windows) or Shift + Option + Command + E (Mac). The image(s) will be exported with the exact same settings as those previously set in the Export dialog.

#44 Editing in Photoshop

Photoshop is one of the most powerful, proficient, functional, and creative image-editing tools that exist. Here we begin taking your images to a whole new level—the fun part! First, we will first look at setting the editing preferences, and second, we will examine how to edit.

Before we begin, dial in your editing preferences. Choose Edit > Preferences (Windows) or Lightroom > Preferences (Mac) to open the Preferences dialog (**Figure 44a**). In the dialog, choose File Format, Color Space, Bit Depth and Resolution for the images to be edited in Photoshop. (For more details see "Which Edit Options Are Best?") You can also define an additional external editor, if you use another program besides Photoshop to edit images. Finally, choose a file-naming convention from one of the Template options.

Figure 44a Before you begin to work on your images in Photoshop, use the Preferences dialog to set up the edit preferences.

There are a few different ways of editing images in Photoshop. The simplest technique involves selecting one or more images in the Library module Grid View or in the Filmstrip and then choosing Photo > Edit in Photoshop.

Raw File-Naming Tip

If you shoot raw images and you're not sure which file-naming template option to select, try Filename; it will keep the same image file name and append a new file extension. For example, if the raw image is named Chris_Orwig_Surfing.CR2, the edited file will be named Chris_Orwig_Surfing.PSD

Which Edit Options Are Best?

The best file format option for editing images in Photoshop is TIFF, which is best at making efficient metadata updates. If you are going to use the PSD format be sure to select the Maximize Compatibility option in Photoshop, or else Lightroom won't be able to read the file. To take advantage of the largest color space, choose ProPhoto RGB. Finally, choose 16 bits/component to best preserve the color details from Lightroom.

For even more editing options, navigate to the Library module Grid View and select one image. Next, right-click (Windows) or Control-click (Mac) the image(s) and choose Edit in Photoshop or Edit in Photoshop as a Smart Object for even more flexibility. If you choose the Smart Object option, you can make changes to your Lightroom adjustments within Photoshop just by double-clicking the Smart Object layer that contains your raw file.

Just when you think you've heard everything about editing in Photoshop—there's more! Again, navigate to the Library module Grid View, except this time select more than one image. Next, right-click (Windows) or Control-click (Mac) the images and choose Edit in Photoshop CS3 (**Figure 44b**). Then select Open as Smart Object in Photoshop, Merge to Panorama in Photoshop, Merge to HDR in Photoshop, or Open as Layers in Photoshop. For more details see the sidebar "New Editing options."

Choose a file-naming convention from one of the template options.

Figure 44b While you are in the Library module Grid View, Control-Click on multiple images in order to view the editing options.

Note

If you are interested in learning more about Photoshop, check out my other Peachpit book, Adobe Photoshop CS3 How-Tos: 100 Essential Techniques.

New Editing Options

Lightroom is equipped with a series of new Edit in Adobe Photoshop CS3 options. In particular, you can choose Merge to Panorama in Photoshop to take advantage of Photoshop's ability to stitch together multiple images. Use Merge to HDR in Photoshop to blend images that have been captured at a wide range of exposure settings. In this way, you can create images with an incredibly wide tonal range. Finally, select Open as Layers in Photoshop, which lets you work with multiple images in one layered Photoshop document.

Develop Module Overview

Comparing digital photography to traditional film photography is sometimes a bit of the stretch, but it keeps the blazing-fast pace of digital photography rooted in a larger historical context. Your personal history also shapes and directs how you work and think about photography. I first discovered the magic of making pictures in high school. My dad's camera and the school's darkroom brought my early images to life.

In Lightroom, the Develop module is where all the fun takes place and we see the image emerge. We don't work with darkness or chemicals anymore, but digital postproduction, processing, and developing are still an art form. This is important to remember, especially if you want to separate yourself from the crowd and create images with impact.

This chapter provides an overview of how to work in the Develop module, laying the foundation for the more complex image-making steps in later chapters. Here we will cover workflow, the interface, shortcuts, presets, and history.

With these next few chapters, my hope is to equip you with necessary technical skills and also to share a bit of the passion I feel is required to create engaging and stunning photographs.

#45 Getting to Know the Develop Module

The panels are one of the most important aspects of the Develop module. A glance at the left and right panels (**Figure 45a**) shows the most frequently used tools in Lightroom. On the top left, the Navigator panel reveals a dynamic preview of the image. Next, in the left panels you will find controls to help track, preserve, and access the history of the edits made to an image. Roll over a thumbnail image in the Filmstrip and see a preview in the Navigator panel.

On the top right, the interactive Histogram panel provides a visualization of image data, which can help when you're evaluating an image. (For more details on how to use the Histogram see Technique #50.) Use both the Navigator and Histogram panels to access broad information about an image.

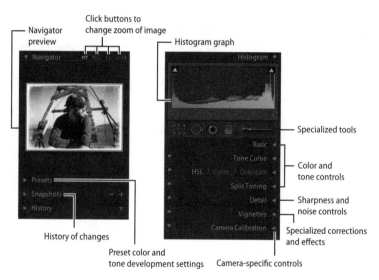

Figure 45a The Develop module panels are organized hierarchically so that what is typically used most often is located at the top.

Because the majority of your work will take place in the right panels, it is important to note how they are organized. The first four panels, where you'll do the bulk of your work, allow you to make a broad range of color and tone changes. Below them are more specialized panels, which enable you to sharpen, reduce noise, add/remove vignettes, and more.

The toolbar is another important feature of the Develop module (**Figure 45b**), providing access to various view modes. Here are rating and ranking displays and buttons that add, remove, or make changes. Or you can use the Navigation buttons to scroll through your images. Click the Slideshow button to enter the Impromptu Slideshow option. Finally, drag the slider to change the Zoom level.

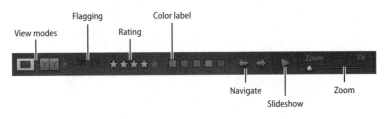

Figure 45b The Develop module toolbar. To toggle open/close the toolbar, press the T key.

Why Is the Develop Module So Simple?

Lightroom was designed by photographers and for photographers. The application tools are organized to complement this specific workflow. In the Develop module the panels and toolbar are placed to make using Lightroom intuitive and simple. The more you know about where the tools reside, the more efficiently you can work. As my friend Lightroom guru Matt Kloskowski says, "I use Lightroom because it makes image processing easy. This ease is like a breath of fresh air that helps bring back some of the fun to image processing."

#**46** Develop Interface and Shortcuts

For me, the Develop module interface is a sight for sore eyes after I've been working on the computer for a long time. It is simple, intuitive, and easy to use. To make your workflow even better, learn these valuable Develop panel shortcuts (**Figure 46a**).

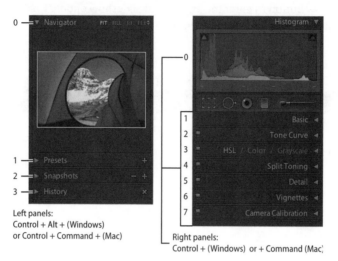

Left panels:
Control + Alt + (Windows)
or Control + Command + (Mac)

Right panels:
Control + (Windows) or + Command (Mac)

Figure 46a Quickly select these functions with keyboard shortcuts: To toggle or open/close, press Control + Alt + (Windows) or Control + Command + (Mac) and the numeric keys corresponding to the functions.

Below are a few more Develop panel interface shortcuts that you will soon use on a regular basis (**Figure 46b**).

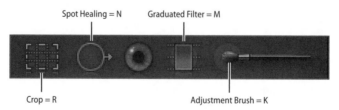

Figure 46b Quickly select these tools from the tool strip with keyboard shortcuts. To toggle or open/close, press the corresponding letter keys. Note: there is no shortcut key for correcting red eye.

Tip
To learn more of the Develop module shortcuts, choose Help > Develop Module Shortcuts, or press Control + / (Windows) or Command + / (Mac).

#**47** Using Develop Presets

The Develop module is equipped with more than 20 default image-processing presets. Presets allow you to save a group of settings and apply them to other photos. You can use the default settings or create your own. Either way, the preset will remain in the Develop module until you delete it.

These presets can be used either as the final image adjustments or as a starting point from where you make further customized changes.

In the Develop module click the Lightroom Presets folder to view the list of default presets. Next, position the cursor over the preset name and the Navigator panel preview will reveal how the image would look with those particular settings (**Figure 47a**). Once you have found the preset you would like to use, click the preset name to apply those settings.

Navigator preview with Antique Light preset

Cursor over the preset Creative-Antique Light

Figure 47a Presets not only speed up your workflow, but the preview may reveal a particular way to process an image that you haven't thought of.

By default, when you save or create presets, they are saved in the Lightroom folder. You can also export the presets with a catalog. This is helpful if you need to share the images and their presets across multiple computers. Choose Lightroom > Preferences and click on the Presets panel. Next, select Store Presets With Catalog.

To create a new custom preset, make changes to the image with the Develop module panel sliders. Next, click the Create New Preset (+) button at the top of the Presets panel or choose Develop > New Preset. This will open the New Develop Preset dialog (**Figure 47b**). Next, work your way through the dialog and then click Create to save the preset. The preset will be added to the list in the Presets panel in the specified folder.

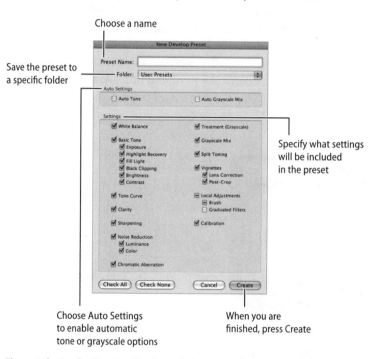

Figure 47b Use the New Develop Preset dialog to specify Preset Name, Folder, and Settings that are to be included in the preset.

Develop Module Overview

#**48** Sharing Develop Presets

Not only are Presets something you can use, but you also can share the wealth. For me this is incredibly helpful, especially when I create a preset on my laptop that I want to use on my desktop. And here's the good news—sharing presets is easy.

Before we begin, please note that Exporting Presets allows you to share the preset without the images (see Technique #47 to export the preset with a catalog and images). To export or share a preset, right-click (Windows) or Control-click (Mac) a preset and choose Export (**Figure 48a**). Next, type a name and click Save. It is as simple as that!

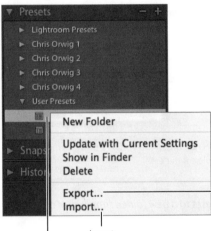

Import

Right-click (Windows) or Control-click (Mac)
in the Presets panel to open menu

Figure 48a Right-click (Windows) or Control-click (Mac) in the Preset panel to create a New Folder, Update with Current Settings, Show in Finder, Delete, Export, or Import.

Once the preset has been exported, you can import it into Lightroom in a similar way. In the Preset panel, right-click (Windows) or Control-click (Mac) where you want to import the preset, and choose Import. Next, double-click the Preset template file (**Figure 48b**). On Mac only, if you double-click a file with an .lrtemplate extension in the Finder, Lightroom will install the file automatically.

Figure 48b When you export a preset, Lightroom saves it as a preset template. These templates can be shared across multiple computers.

Tip
If you would like to move a preset to a new folder, simply click and drag it to the new location.

Finding Presets

If you do a quick Google search for Lightroom Presets, you will find a wide range of Web sites that offer free presets that you can download and import into Lightroom. Here are a few noteworthy sites:

www.lightroomkillertips.com/archives/presets

www.lightroomextra.com

http://inside-lightroom.com
(download and read their PDF: *The Anatomy of a Preset*)

http://lightroompresets.com

www.ononesoftware.com/detail.php?prodLine_id=33

#49 Using History and Snapshots

The History and Snapshot panels (**Figure 49a**) allow you to save and track the progress of your image editing, so you can always go back and undo what has been done.

The History panel keeps a detailed step-by-step record of any adjustment made to the photo. The adjustments recorded include everything from an applied Develop preset to an added one-star rating. To take full advantage of the History panel, position your cursor over the list in the History panel to view the different effects in the Navigator panel. If you determine that one of the effects is best, click on it to revert the image to that state. When the History panel list of image states becomes too long, click the X icon to remove them all. But use caution, as this will permanently delete all the of History states.

The Snapshots panel was created for use either by itself or in tandem with the History panel. For example, if the History panel list gets too long, you can click on a particular History state and create a snapshot of it by clicking the plus icon in the Snapshot panel. Continue to create snapshots of the important History states and then clear them all. Once you have created snapshots, position the cursor over a snapshot name to view a preview in the Navigator panel, or click on the snapshot name to apply the desired settings to the image.

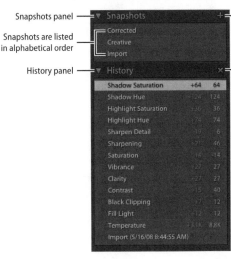

Snapshots panel
Snapshots are listed in alphabetical order
History panel
Click the plus icon to create a new snapshot
Click the X icon to clear the list of history states

Figure 49a The History and Snapshot panels can give you access to Preview or revert an image to previous settings.

Note
For ease of use, the snapshots that you create will be listed alphabetically in the Snapshots panel.

Develop Module— Basic Adjustments

What chapter in this book is most important? It's an impossible question to answer. It's not about one chapter but the cumulative effect of all the chapters to enhance your experience with Lightroom. However, I would say in general that the chapters on the Develop module are the most important in the book. The Develop module is where we tackle the real nuts-and-bolts details of image processing, and it's where the image begins to emerge.

The majority of my photographic work is shot with digital cameras. I do have an old wood-and-brass large-format camera that I really enjoy. It takes a long time to set up, a long time to make the image, a long time to scan the image, and a long time to complete the postproduction. This process has taught me patience and to not give up on images so quickly. Some of my best work has emerged through the process. Thankfully, Lightroom is much quicker, but it is still valuable to have that slow perspective. As you work on an image in the Develop module, be sure to experiment with different settings and watch for unexpected results. In addition, spend time reading this and the other Develop module chapters to improve and refine your work.

Finally, as you are learning about using the Develop settings keep in mind that you will get the most out of these adjustments using raw images. Of course, Lightroom is not limited to raw images, and these settings will work very well with JPEGs and TIFFs as well.

In this chapter we will focus on the more commonly used Develop module adjustments: the Histogram, White Balance, Modifying Tone, Clipping, Improving Presence, and Virtual Copies.

#50 Understanding and Using the Histogram

The Histogram (**Figure 50a**) is a dynamic tool that serves as a visual representation of the image data that is useful for evaluating and modifying the image. In more specific terms, a histogram reveals the number of pixels at each luminance percentage. A histogram that continues from the left to right side reveals that the photo has a good exposure and takes full advantage of the tonal scale. In contrast, a histogram that leans heavily to one side or the other reveals under- or overexposure. In addition, a histogram with spikes reveals that the image has some sort of clipping (loss of image detail).

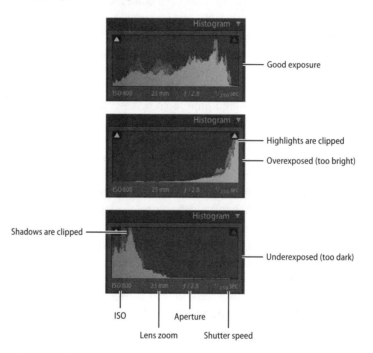

Figure 50a The histogram displays the brightness values of the image's color channels and is useful for evaluating and correcting images. You will find some valuable camera metadata at the bottom of the panel.

The histogram isn't just something nice to look at; it is a fully functioning and interactive tool. To view any information that is clipped, click the left triangle (shadows) or right triangle (highlights).

For even more control, position your cursor over the histogram to reveal the different tonal areas of the image: Blacks, Fill Light, Exposure, and Recovery (**Figure 50b**). Next, click and drag to the left or right to decrease or increase the values of those tones.

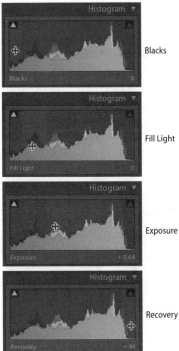

Blacks

Fill Light

Exposure

Recovery

Figure 50b Position the cursor over the histogram to reveal and target a specific tonal region. Next, click and drag to make changes and improve the overall tonal value of the image without ever having to open the Develop module panel again.

Histogram Details

Histograms run left to right, dark to bright. The left side of the histogram depicts the pixels with 0.0 percent luminance (brightness); the right side depicts 100 percent luminance. The histogram also contains Red, Green, and Blue color-channel information. To display the different channel values, the histogram has a color graphic where Gray appears when all three channels overlap. Next, yellow, magenta, and cyan appear when two of the RGB channels overlap (yellow equals the Red + Green channels, magenta equals the Red + Blue channels, and cyan equals the Green + Blue channels).

Tip
To toggle on/off both shadow and highlight clipping press the J key.

#51 Correcting White Balance

Color correcting images, also called white balancing, is actually a complex process, but with Lightroom it is a breeze. To white balance an image, follow the steps below:

1. Navigate to the Develop module and open the Basic panel to view the white balance controls (**Figure 51a**).

2. Click the white balance selector tool or press the W key.

3. Position the cursor over a color that should be neutral. Try to avoid something that is pure white—in fact, light gray works best. As you hover over the image you will notice a zoom view of the pixels showing the RGB values (**Figure 51b**). In addition, you will discover that the Navigator preview will change to display a preview of the white balance if the area was clicked.

4. Click in the area that looks best.

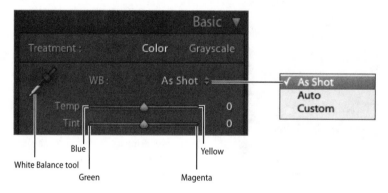

White Balance tool

Blue
Green

Yellow
Magenta

Figure 51a Because color balancing is typically your first step when editing images, the white balance controls are at the top of the Basic panel. When you need color accuracy, white balance comes first because it neutralizes the image.

Auto White Balance

To have Lightroom automatically correct the white balance, click on As Shot > Auto or press Shift + Control + U (Windows) or Shift + Command + U (Mac). While this option will not provide the best results, it's handy when you are in a hurry or need a starting point.

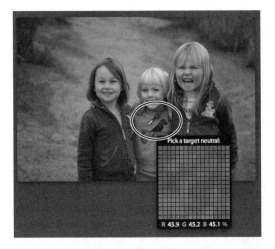

Figure 51b To view the white balance loupe select the white balance tool and position the cursor over the image.

There are a few additional options in the white balance tool in the toolbar, located beneath the image. First, the Show Loupe option toggles off/on a close-up view of the pixels and their RGB values (as shown in **Figure 51b**). Next, the Scale slider changes the zoom of the Loupe. Select Auto Dismiss so that after you have clicked on this image the tool is automatically returned to its dock in the Basic panel. Click Done to exit the tool.

In addition to using the white balance tool, you can fine-tune the color balance or add a subjective color shift using the Temp slider (controls yellow or blue shift) and Tint slider (controls magenta or green shift), as shown in the Basic panel screen shot above (Figure 51a).

Tip

To learn more about adjusting white balance in Lightroom, watch this free tutorial movie: www.adobe.com/go/learn_lr_video_wb.

Why White Balance?

One of the trickiest aspects of digital photography is color correcting images, or white balance. Different light sources have different color temperatures. The sun at midday is white and bright, and at dusk it's yellow and warm; shadows cast by sunshine can be cool and blue. Consider if you photograph a golfer wearing a white shirt and standing on bright green grass. The image and shirt will appear to have a green tint from all the reflected light bouncing off the grass. To reproduce color accurately, especially with complex lighting situations, it is critical that you correct the white balance of an image.

#52 Modifying Basic Tone

To make tonal adjustments to your image use the tone controls in the Basic panel: Exposure, Recovery, Fill Light, Blacks, Brightness, and Contrast (**Figure 52**). Let's examine each slider closely, because the Develop module Basic adjustments are so significant. As you work, make sure to keep an eye on the histogram (as discussed in Technique #50) and watch the results on the image itself. In this way, you will be able to make changes that are balanced based on the histogram and visually pleasing based on the image.

Exposure Slider Values

The Exposure slider values are in increments similar to f-stops on traditional film cameras—an adjustment of +2.00 is similar to increasing the exposure by two f-stops.

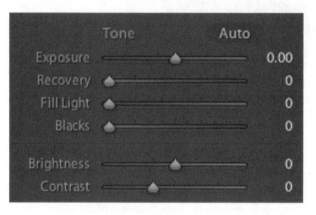

Figure 52 The Tone control in the Basic panel provides six adjustment sliders.

Exposure

The Exposure slider is one of the most far-reaching adjustment tools for making dramatic corrections and improvements. You can use it to set the overall brightness of the images (keep in mind that it does have a greater effect on the brighter tones). Be careful not to change the exposure too dramatically when using this tool, as it may increase the noise (graininess) of the image.

Recovery

The Recovery slider reduces the tones of extreme highlights and recovers highlight details from overexposure. It is one of the more delicate and subtle tools, but don't overlook how important it is for making small refinements. Recovery works best with raw files, where there is still detail available. Lightroom can interpolate for JPEG and TIFF files, but not as effectively.

Fill Light

The Fill Light slider allows you to subtly lighten the shadows to reveal more detail without brightening the dark blacks. It is best to make small adjustments with this slider, as over applying it can reveal image noise and add an unnatural look to the image.

Blacks

The Blacks slider can be used to make strong adjustments that increase the areas that are black. This slider mostly affects the darkest tones.

Brightness

The Brightness slider adjusts image brightness, mainly affecting mid-tones. Typically, it is best to modify the overall tonal scale by setting Exposure, Recovery, and Blacks. After you have completed this, set the overall image brightness. Finally, go back and readjust the Exposure, Recovery, or Blacks sliders as needed.

Contrast

The Contrast slider affects the mid-tones by increasing or decreasing the tones to change the image contrast. When making contrast adjustments pay attention to your shadows and highlights to make sure you don't accidentally clip any tones and lose detail (see Technique #50).

Tip

To learn more about recovering highlight detail in overexposed photos, watch this free tutorial movie: www.adobe.com/go/learn_lr_rec.

Auto Tone

To Automatically correct the tone click on the Auto button or press Control + U (Windows) or Command + U (Mac). Lightroom will set the sliders to maximize the range of tones while minimizing highlight and shadow clipping.

Is Tone Really Basic?

Tonal adjustments are some of the most important and advanced changes you will make in Lightroom. Found in the Basic panel, these adjustments are only basic in that they are foundational and easy to apply. With them you actually perform some of the most important steps involved in digital postproduction.

#53 Correcting Clipping

What Is Clipping?

One of the most overlooked photographic problems in digital postproduction is clipping, or loss of detail. It is easy to get carried away with the sliders and not pay attention to the detail. The end result can be an image that looks good on-screen but you can't actually print.

Clipping problems occur because the image on the monitor is created via light, and 100 percent black or white does not necessarily look bad on-screen. When an image is printed with ink, 100 percent black or white does not reproduce well. There can be problems with clipping in other color channels as well, with even worse results.

To prevent unnecessary clipping, or loss of image detail, before you begin to make tonal adjustments, turn on the clipping indicators (**Figure 53a**). To do this click on the triangle icons at the top of the histogram or press the J key to toggle on the feature to show clipping. Once this has been turned on, a colored clipping indicator on the image means one or two channels are clipped. Using this information, you can make corrections to prevent clipping (loss) of important details in the image. If the clipping notification on the image becomes distracting, press the J key to toggle off the Show Clipping feature.

Clipping indicator—Blacks · Clipping indicator—Whites

A white outline shows that the
indicator has been turned on

Figure 53a As you make adjustments, click on the clipping indicators (triangles) at the top of the histogram so you can see when color channels are being clipped.

With the clipping indicators on, examine the image (**Figure 53b**). Next, move the Blacks, Exposure, and Recovery sliders. As you move the sliders watch the clipping indicator highlight on the image. Adjust the sliders until the highlight has been significantly reduced or removed.

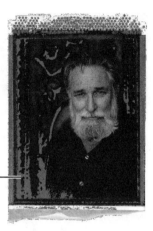

The highlighted area that appears solid in this image reveals clipping

Figure 53b With the clipping indicators turned on you can quickly identify areas of clipping that you might have otherwise overlooked.

Tip

Rather than turning on the clipping indicators, you can quickly preview the clipping in the photo by positioning the cursor over the triangle icons in the histogram. To preview clipping in the photo, move the mouse over the clipping indicators.

Good Exposure is Essential

After photographing a surfing legend, I was so excited to see the results that I immediately processed the film, held my breath, and looked at the first image. To my dismay, the exposure was off and there was no detail in the eyes. But the next half-dozen shots turned out to be amazing. There is something powerful about the costly lessons you learn from situations like this: Correct exposure is paramount. And I've found it is even more important with digital capture. You have flexibility with raw processing, but don't get lazy. The best solution is to get the image right on camera.

#54 Improving Presence

While the name of the next group of sliders in the Basic panel is a bit vague, the actual sliders are anything but that, providing measurable contrast and color enhancements. The Presence sliders are Clarity, Vibrance, and Saturation (**Figure 54a**).

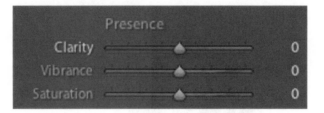

Figure 54a Use the Presence sliders to add either subtle or notable image contrast and color enhancements.

Clarity

Use the Clarity slider to add local contrast, which adds dimension or depth to an image. Think of this slider as adding mid-tone contrast and sharpening, but keep in mind the effect is subtle. First, zoom to 100 percent to see the effects (**Figure 54b**). Next, increase the setting until you notice a halo

Before—without Clarity After—with Clarity

Figure 54b The effect of adding clarity can be seen in a before-and-after view. Before is on the left, after on the right.

near high-contrast edges. Once you see the halo, reduce the setting until the halo has been diminished.

Vibrance

The Vibrance slider allows you to add or remove saturation in a nonlinear or intelligent way. It affects the less-saturated colors and has less of an effect on the more-saturated colors. It also protects skin tones, so if you increase the vibrance on a photograph of a person, it won't over-saturate the skin tones, but will add color variety and increased saturation in the more muted colors.

Saturation

The Saturation slider adjusts the saturation of all image colors equally, from −100 (grayscale) to +100 (double the saturation). Be careful not to over-saturate your images, as this can result not only in an unnatural look and colors that are blocked up, but to clipping (loss of detail) as well.

Learn More About Presence

Watch one of these free tutorial movies from the following Web sites:

www.chrisorwig.com/clarity

www.adobe.com/go/learn_lr_vib

www.adobe.com/go/learn_lr_video_vibrance

#**55** Modifying Contrast with the Tone Curve

The Tone Curve controls give you the ability to modify the tonal values of your image in a distinct way. If you have ever made curves adjustments in Photoshop you will discover that curves in Lightroom are quite a bit different. The Lightroom tone curve attributes are controlled by sliders, and the adjustments are more limited in comparison to Photoshop Curves. But the end result is a set of powerful controls that are effective and easy to use.

Let's examine the elements of the Tone Curve panel (**Figure 55a**). The graph represents the tonal scale, with darker tones on the left and brighter tones on the right. The Split Point controls expand or restrict the tonal range affected by the different sliders. The Highlights, Lights, Darks, and Shadows sliders, as their names suggest, enable you to adjust specific areas of the image. The Point Curve menu allows you to select a predefined contrast level. The Targeted Adjustment tool can be used to hover over the image and make adjustments in a particular area.

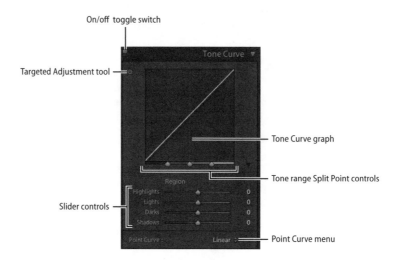

Figure 55a The Tone Curve controls enable you to make focused adjustments. In addition, the controls automatically prevent you from intentionally or accidentally over processing the image. The final result is a set of highly effective controls for making subtle or strong tonal adjustments to a photo.

To make an adjustment using the Tone Curve panel, use one of the techniques below:

- Click on the curve line and drag up or down, or press the up or down arrow keys to increase (up) or decrease (down) in the brightness level.

- Use the slider controls to modify the tonality by dragging the sliders to the left (darken) or right (brighten) the particular tonal region.

- Click on the Targeted Adjustment tool in the panel (as shown in Figure 55a) and hover over the image. At the desired part of the photo image (**Figure 55b**), click and drag up or down.

- Click on the Point Curve menu and choose Linear (no added contrast), Medium Contrast, or Strong Contrast.

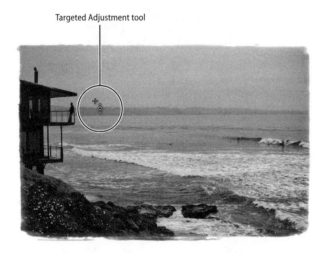

Targeted Adjustment tool

Figure 55b When you hover the cursor over the image using the Targeted Adjustment tool, the cursor changes appearance. Next, click and drag up or down to change the tonality of that area.

Tip
While using the targeted adjustment mode you can use the up and down arrow keys to increase or decrease the settings.

General Tone Curve Tips

Tone Curve lets you limit your adjustments to specific regions. To further customize the adjustments, move one or more of the three Split Point controls (**Figure 55c**). These work like sliders and limit how far an adjustment on the curve will affect the image. You can really focus the adjustments you make by clicking on the curve line or by using the sliders. For example, if you would like to limit a shadows adjustment, first mover the Shadows slider to -100. Next, move the far left Split Point control to the left. This will limit the adjustment to the darkest tones. Using the Tone Curve panel in combination with the Basic panel will lead to the most precise results.

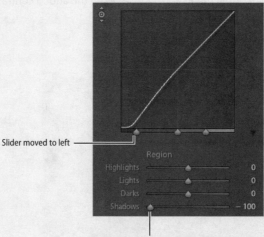

Slider moved to left

Shadows slider moves from 0 to 100

Figure 55c

Learn More About Tone Curve

To learn more, watch this free tutorial movie: www.adobe.com/go/
learn_lr_video_curve.

#56 Creating Virtual Copies

The addition of virtual copies to the digital imaging workflow has been an important milestone. Not only are virtual copies a great new feature, they require a new way of thinking. Virtual copies are nondestructive, and they allow you to have multiple versions of your photos with only a small, insignificant increase the file size (as opposed to creating a real copy of your image, which would double the file size). In addition, you can modify an image in many ways without being concerned about losing information or increasing file size.

With virtual copies the "copies" don't actually exist; rather, they are metadata files in the Catalog that allow you to display the master image in a new way, without duplicating the image's pixels and increasing the file size.

To create a virtual copy, select one or more images and choose Photo > Create Virtual Copy, or press Control + ' (Windows) or Command + ' (Mac). In the Grid view the virtual copy is identified by a page-turn icon on the lower-left corner of the thumbnail (**Figure 56**).

Creativity and Virtual Copies

Once you start using virtual copies you will discover how they open up a whole new artistic realm—creating completely different versions of an image, including new crops, Develop settings, labels, ranks, ratings, etc. You'll be able to take creative risks that will help you arrive at new image possibilities.

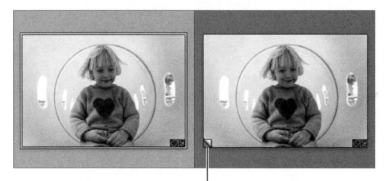

Virtual copies are identified by a page-turn icon on the lower-left corner of the thumbnail.

Figure 56 Virtual copies are conveniently located to the right of the master file.

#57 Applying Settings to Other Images

One advantage of using Lightroom is that you can edit one image and then seamlessly apply the settings (whether it's crop, color, tone, etc.) to other images. This is especially helpful if you have a group of images that were captured under similar conditions with the same camera, lens, and lighting. You can use and reuse your detailed adjustments from the current photo and apply them by pasting them to or syncing them with another photo.

To copy settings to multiple images, navigate to the Develop module. Next, modify the image. Then, at the bottom of the left panel click the Copy button and choose Edit > Copy, or choose Settings > Copy Settings. This will open the Copy Settings dialog (**Figure 57a**). Select the settings you want and click Copy. To apply these settings other photos, use the Paste button at the bottom of the left Develop module panel, choose Edit > Paste, or choose Settings > Paste Settings.

Figure 57a Use the Copy Settings dialog to specifiy what settings you will copy and paste or apply to other images.

Sync Settings is another technique for applying settings to other images. In the Filmstrip, click on the image with the settings you would like to use. Next, Control (Windows) or Command (Mac) + click on one or

more other images. Then choose Settings > Sync Settings, or press Shift + Control + S (Windows) or Command + S (Mac), or click the Sync button below the panels on the right (**Figure 57b**).

Figure 57b Use the Sync button to synchronize settings across multiple images.

Tip
You can modify the Sync button functionality by holding Alt (Windows) or Option (Mac) and clicking on the button. This will change the button to Autosync, and any change of settings will apply to all selected photos— without your going through the Synchronize Settings dialog.

Note
While this chapter focuses on the Develop module, you can also copy settings in the Library module by choosing Photo > Develop Settings > Copy Settings. Next, define the settings you want to copy and click Copy. Finally, choose Photo > Develop Settings > Paste Settings.

Quick-Copy Tip

To speed up the process of copying settings to other images, try the following shortcut:

• Click on the image in the Filmstrip from where you would like to copy the settings. Press Control (Windows)/Command (Mac) + C to copy the settings. Open the Copy Settings dialog and choose what you would like to copy.

#58 Viewing Before and After

In traditional film photography, the image emerges in the developing tray. Images also "emerge" in Lightroom: You slowly build up the desired result by working with the various Develop module controls. This means it is helpful to compare the final state of the image to your original.

The quickest way to compare a starting version to a final version is to press the backslash (\) key to toggle back and forth between the two. For even more comparison views, choose an option from the pull-down menu (**Figure 58a**) or click on the View icon in the toolbar (**Figure 58b**) and choose the appropriate option.

View	Window	Help	
Hide Toolbar			T
Cycle Loupe View			
Toggle Zoom View			Z
Zoom In			⌘=
Zoom Out			⌘−
✓ Loupe			D
Before / After			▶
Crop			R
Spot Removal			N
Red Eye			

Left / Right	Y
Top / Bottom	⌥Y
Before Only	\
Split Screen	⇧Y

Figure 58a Try all of the different comparison views and discover which one works best for you.

Figure 58b The same comparison views can be accessed by the pull-down menu (shown above) or the comparison icon located in the Develop module toolbar.

In either option, the Before view displays the photo as it was originally imported, including any presets that were applied. The After view shows

changes as you make them. For example, if you chose Before/After > Left/Right split, you will see the photo divided into two views. (**Figure 58c**).

Tip
Right-click (Windows) or Control-click (Mac) on a history step and choose Copy History Step Settings to Before. In this way you're not restricted to having the Import state as your Before view.

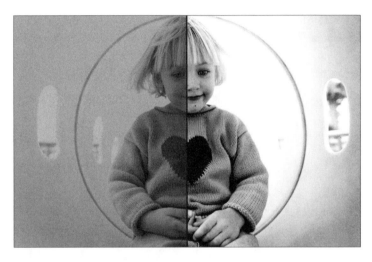

Figure 58c The Before/After–Left/Right Split view shows you a full-sized image, which is helpful for evaluating adjustments.

Note
When you're comparing images in a split view, zooming and panning are synchronized in the two views.

Juxtaposition
Photography is a medium of comparison, contrast, and juxtaposition. Your best images are discovered by viewing two photographs side by side, a process in which ordinary images make good photographs look even better. If you want to become an accomplished photographer, learn to improve the way you edit by taking advantage of Lightroom's comparison features and shortcuts.

Develop Module— Specialized Adjustments

The Develop module is where all of the photographic magic happens, and the time you spend with these chapters will help your photography improve by leaps and bounds. Sometimes I get carried away working in the Develop module because it is so easy to arrive at compelling results and it's also incredibly fun. My hope is that you will learn more about the technical aspects of the module controls and with these new skills reignite your passion for capturing images.

In this chapter, we will go beyond the essentials and cover a range of specialized Develop module controls. We'll focus on Hue/Saturation, Grayscale, Split Toning, Reducing Noise, Sharpening, Chromatic Aberration, Cropping, Vignetting, and Camera Calibration.

#59 Changing Hue, Saturation, and Luminance

Complexity Made Simple with HSL

The complex relationship between color and tonality is made simple with the Hue, Saturation, and Luminance (HSL) controls. These controls will not only help you make color-specific edits that will dramatically improve your images, but also will give you a new appreciation of color that will expand what you see and how you capture.

To use the Hue, Saturation, and Luminance (HSL) controls open the HSL/Color/Grayscale panel in the Develop module (**Figure 59a**). Next, click on the buttons at the top to select the controls for Hue, Saturation, Luminance, or All, as shown in the screen capture below. Next, drag the sliders to the left to decrease or to the right to increase the particular aspect of the image. At times it is difficult to determine which slider will affect a particular area of an image. When that's the case, click on one of the Targeted Adjustment tool icons. Position the tool over an area of an image and drag down to decrease or up to increase the effect.

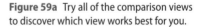

Figure 59a Try all of the comparison views to discover which view works best for you.

The best way to understand how these controls work is by seeing an example. Often in landscape photography, you need to darken the sky (**Figure 59b**). To do this click on the Targeted Adjustment tool for the Luminance sliders. Next, position the tool over the sky and then click

and drag down (**Figure 59c**). The final result is a much more visually interesting image (**Figure 59d**).

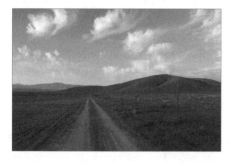

Figure 59b The original, unedited image.

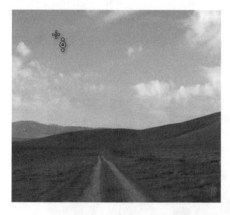

Figure 59c The Targeted Adjustment tool allows you to make adjustments to specific areas of an image by simply positioning the tool over an area and then clicking and dragging up or down.

Figure 59d The final image with the sky darkened after changing the luminance with the Targeted Adjustment tool.

#60 Converting to Grayscale

Photographer Rodney Smith once told me, "Black-and-white is simply more emotional." I agree. There is something incredibly believable, powerful, engaging, and intriguing about black-and-white photography. Learning how to convert to grayscale (as it's called in Lightroom) can be very fruitful.

The quickest way to convert to grayscale is to choose Settings > Convert to Grayscale or to press the V key. This will convert the photo based on the Color Temperature controls in the Basic panel. While this conversion is not always best, it can be a good way to check to see if an image with look good in black-and-white, or it may simply be a nice starting point to make further adjustments.

Another technique is to open the HSL/Color/Grayscale panel and then click the Grayscale button (**Figure 60a**). This will automatically convert the image to grayscale based on the Color Temperature controls. Next, move the sliders or use the Targeted Adjustment tool to dial in an appropriate black-and-white conversion. The final result of using the grayscale

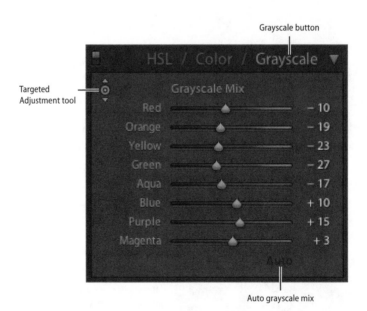

Grayscale button

Targeted Adjustment tool

Auto grayscale mix

Figure 60a Use the Grayscale panel controls to change the luminance (brightness) values or the "colors" of the image. The colors have been removed, but you can still modify the brightness of the areas based on the original colors.

controls can be a dramatic and compelling image (**Figure 60b**) as opposed to one obtained by simply pressing the V key for the default conversion (**Figure 60c**).

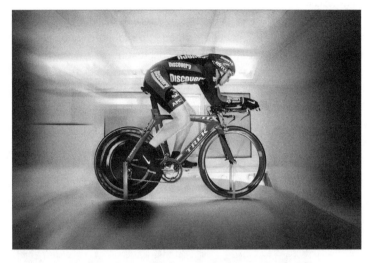

Figure 60b The final and best result of using the Grayscale panel controls.

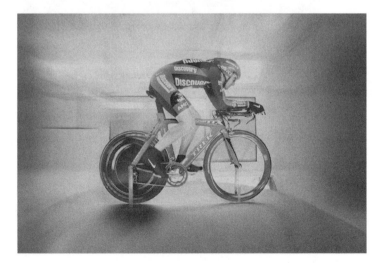

Figure 60c The less-desirable result of using the default grayscale conversion of Settings > Convert.

#61 Split Toning

Sample a Color from the Image

When using the color chip you can choose a color from the box or directly from the image. To sample a color from the image, click the color chip icon and then drag the cursor out of the box and onto the image. Lightroom will then sample the color from the image. While this is helpful with split toning, keep in mind that this technique can be used with the color chips in the Web and Slideshow modules as well.

Advanced Tips for Split Toning

To get even more out of the Split Toning Hue/Saturation menu, while in the Highlights menu, press Control + (Windows) or Command + (Mac) to click and drag in the color sample area to select a hue for the shadows. Conversely, if you are in the Shadows menu, Control + (Windows) or Command + (Mac) to click and drag in the color sample area to select a hue for the highlights.

Split toning can be used to add a color tone to the highlights or shadows of a photo. Traditionally, split toning was used to tone black-and-white images, and in Lightroom it can be used to create intriguing effects on both grayscale and color images.

To split tone an image, open up the Split Toning panel in the Develop module (**Figure 61a**). The panel is divided into Highlights and Shadows so that you can add tone to the brighter or darker tones. Next, use the Hue slider to choose a specific color and the Saturation slider to determine color intensity. Typically, when the saturation amount is low it is difficult to choose a specific color with the Hue slider. In this case, hold down Alt (Windows) or Option (Mac) and click and drag the Hue slider to view a preview of the hue at 100 percent Saturation.

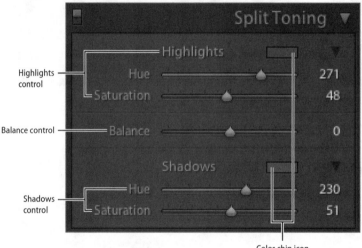

Figure 61a Use the Split Toning panel to add a unique color-tone effect.

For even more control over the split tone effect, click on the color chip icon to open up the Split Toning Hue/Saturation menu (**Figure 61b**). In this menu, click in the color sample area to select a hue. Or click and drag over the image itself to select a color right from the image. In addition, you can use the Saturation slider to change the Saturation.

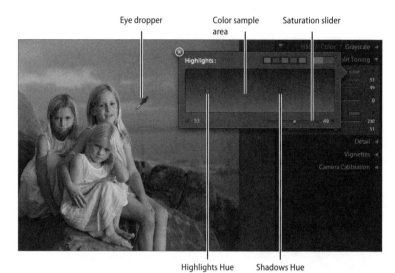

Eye dropper Color sample area Saturation slider

Highlights Hue Shadows Hue

Figure 61b The Split Toning Hue/Saturation menu adds a new level of ease to creating the perfectly split-toned image.

Split Tones and Traditional Film Photography

The idea of split-toned images comes from the practices of traditional black-and-white film photography. Split tone refers to both warm and cold tones simultaneously present in an image. Conventional toning (like sepia) will create a uniform brown tone, while split toning allows multiple colors like reds and blues or green and violets in your black-and-white image.

Another tip, originally passed on by photographer Martin Evening, is to use color split toning as the basis for a cross-processing effect similar to that produced by processing E6 slides in C41 negative-film chemicals.

#62 Reducing Unwanted Noise

While there are many reasons to celebrate digital photography, there are also a handful of challenges. One of the most common is dealing with noise in the shadow areas that results from high ISO settings or from low light. The problem with noise is that it contains both brightness and color problems. The good news is that fixing typical types of noise in Lightroom is a snap with the Detail panel (**Figure 62a**).

Zoom level adjustment tool

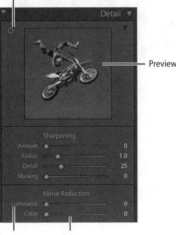

Preview

Luminance Color

Figure 62a The Noise Reduction controls are part of the Detail panel in the Develop module.

To begin the process, zoom the image to 100 percent to see the actual details of the image. Next, click in the preview window to change the zoom of the preview. To change the area of the image revealed in the preview window, either click and drag to reposition the image, or select the zoom level adjustment tool and hover over the image. As you hover over the image, the preview will be updated.

Next, use the Luminance and Color sliders to remove the noise. The Luminance slider controls noise caused by brightness. The Color slider removes noise that results from color artifacts by reducing the color variance.

The first image in **Figure 62b** was captured with an ISO of 1600 as a test and had excessive noise in the sky. By simply moving the Color and Luminance sliders up to approximately 20, the noise was successfully removed in the bottom image. But as you reduce the noise of the image you also soften the edges. As a result, noise reduction techniques work

best in when used in unison with the sharpening controls (which will be discuss in the next technique). In other words, after you reduce the noise, be sure to go back and increase the sharpening to compensate for the softening from the noise reduction.

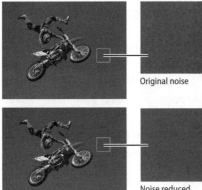

Original noise

Noise reduced

Figure 62b The end result of the Noise Reduction sliders is convincing.

#63 Capture Sharpening

Advanced Sharpening View

When you are sharpening a photo it is difficult to determine the exact effect of a particular slider. To see the effect in a new way press Alt (Windows) or Option (Mac) and click and drag the sliders. This will reveal a grayscale preview of the Amount, Radius, and Detail sliders that will help you see exactly how the sharpening is working. For the Masking slider it will reveal a white and black mask in which white reveals or allows sharpening and black conceals or limits sharpening. At zero the mask is completely white, meaning the whole image is sharpened.

Whether you shoot and capture raw or JPEG images, you will find that all images need a certain level of capture sharpening in order to correct any softness of the image that results from capture. Later we will discuss output sharpening (in Tip #94) in order to complete the picture. Sharpening is tricky, as it is easy to over-sharpen photos. It is a good idea to proceed delicately and to spend adequate time learning how the sharpening tools work.

You can access the sharpening controls from the Develop module Detail panel (**Figure 63a**). To sharpen successfully, zoom the image to 100 percent to view the details. Next, click in the preview window to change the zoom of the preview. To change the area of the image revealed in the preview window either click and drag to reposition the image or select the Detail zoom level adjustment tool and hover over the image. As you hover over the image, the preview will be updated.

Zoom level adjustment tool

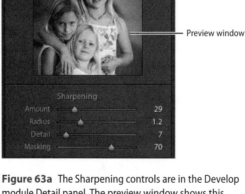

Preview window

Figure 63a The Sharpening controls are in the Develop module Detail panel. The preview window shows this lower resolution image at 100 percent.

To begin the sharpening process, try one of the two sharpening presets in the left side Presets panel (**Figure 63b**):

Sharpen – Landscapes to add a moderate amount of overall sharpening while sharpening many of the smallest details of the image.

Sharpen – Portraits to add a moderate amount of overall sharpening while protecting the small details from being sharpened. The sharpening will be applied mostly to the areas of high contrast (like edges), but not to small details in the skin, which would be unflattering.

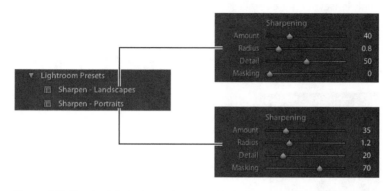

Figure 63b Use the default sharpening presets in the Preset panel as a starting point.

Next, modify the sharpening sliders to create the best sharpening mix. The best sharpening results from combining all four sliders. Let's take a look at how each slider contributes to the sharpening process:

Amount – Controls the overall intensity of the sharpening. Be careful not to increase this amount too much, as it can lead to an unnatural look. If the amount goes into the red area of the slider, be sure to use the controls below (and the noise reduction controls, described in Technique #62) to scale back the sharpening.

Radius – Controls how far out from an edge the sharpening extends. A low radius setting keeps the sharpening close to the edge. A high radius setting expands the reach of the sharpening. If you notice a halo around the edges of your image, decrease the radius to reduce it.

Detail – Controls sharpening on small details. A low amount prevents the sharpening of small details, while a high number sharpens small details.

Masking – Controls where the sharpening is applied. The higher the number, the larger the mask, which limits the sharpening to the edges or to the areas of high contrast.

Cooking, Spices, and Sharpening

The best cooks use spices and seasoning in a subtle way that complements rather than overpowers the food. In the same way, when you are sharpening keep in mind that the sharpness of the photo is not the point. The point is to create an image that is engaging, intriguing, and beautiful. Seasoning your images with just a dash of sharpening works best.

#64 Removing Chromatic Aberration

Recently one of my photography students said in jest, "I'll give you $20 if you can tell me what chromatic aberration means." The term does suggest a strange and deeply complex subject, but it's quite simple. Chromatic aberration refers to the color fringing that is a common problem with wide-angle lenses (for more details see "More on Chromatic Aberration"). You may notice a color edge (for example, red or cyan, etc.) on the side of an object in an image. If you come across this problem, fixing it will be a breeze if you use the Chromatic Aberration controls located in the Detail panel (**Figure 64**).

More on Chromatic Aberration

Chromatic aberration is the result of the lens bending light to focus it. Light is made of different wavelengths, and they bend at slightly different angles. Generally lens makers use series of lenses to correct this internally, but for wide-angle lenses, the cost can be prohibitive, especially for zooms. The end result often is undesirable color fringing around the edges of the photographic subject matter.

Zoom level adjustment tool

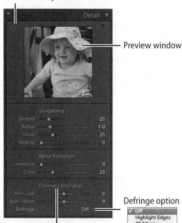

Preview window

Defringe option

Chromatic Aberration controls

Figure 64 The Chromatic Aberration controls are located in the Develop module Detail panel.

To fix chromatic aberration, zoom in to an area of the image near the edge or corner. Click the zoom level adjustment tool and position it over the area you would like to inspect. The preview window will display the area. Or click and drag in the preview window to change the area that is previewed. Next, look for color fringing along the edges of the objects in the photo.

Use the controls to fix the fringe color. The Red/Cyan slider allows you to fix red/cyan fringing. For example, if you notice a red fringe, drag the slider to the left. The Blue/Yellow slider allows you to fix the blue/yellow fringing—if you notice a blue fringe, drag the slider to the left.

Finally, select a defringe option from the pull-down menu. Try choosing Highlight Edges first so that the correction is limited to the highlighted area. If that is not sufficient, choose All Edges to apply the color fringing correction to all edges. If you select this option, be careful to watch for small gray lines or undesirable effects. If you notice any negative effects, go back to Highlight Edges or choose Off to turn off the defringing option.

#65 Crop and Straighten

It is always best to crop and compose on camera. Sometimes, however, you just don't get the composition right. In addition, you may simply want to recompose the image for creative purposes. In either case, cropping in Lightroom will soon become an integral part of your postproduction workflow. In addition, unless you are using a full-frame high-end camera, you have only about a 90 percent view of the actual shot through the viewfinder, so the final composition will vary slightly from what you saw on camera. As a result, in many situations it becomes essential to crop in postproduction. Either way, let's first look at how to apply a basic crop, and second, examine some of the other crop and straighten options.

Basic Crop

First, to select the Crop tool choose View > Crop, or press R, or click on the Crop tool icon under the Histogram in the Develop module (**Figure 65a**). After you select the Crop tool, an outline with adjustment handles will appear on top of the photo. To adjust the crop, drag one of the adjustment handles and reposition the photo within the crop frame by dragging the photo. When you have finished, press Return or Enter to accept the crop.

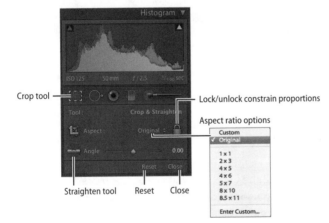

Figure 65a The Crop tool is located In the tool strip, below the Histogram. You can choose from preset aspect ratios or else enter custom ones.

Advanced Crop Tips

To move the whole crop, move in evenly from the edges, click-drag while holding Alt (Windows) or Option (Mac). On the other hand, if you want to temporarily lock the aspect ratio of the crop, click-drag while holding Shift. Finally, in order to create a more freeform crop, you can draw the crop directly on the image by simply clicking and dragging.

Grid Overlay

One of my favorite crop options is the grid overlay. After you have selected the Crop tool you will notice a grid overlay on the image. To change the grid overlay press the O key to cycle through six different options. This is valuable to help you determine what crop will work best. The different grid overlay views will also teach you about composition (**Figure 65b**).

Straighten tool Grid overlay showing rule of thirds

Crop handles

Part of original image is grayed out, showing that it will be cropped

Figure 65b The grid overlay is a powerful evaluative tool to determine what crop works best. If you find the overlay distracting, you can turn it off by choosing View > Tool Overlay > Never Show.

Aspect Ratio

After you have selected the Crop tool you can access more aspect ratio options. First, use the padlock icon to control whether the crop aspect ratio is constrained or not. If the padlock is locked, the crop aspect ratio is constrained; if it is unlocked, the crop aspect ratio is freeform. Next, choose an aspect ratio from the pop-up menu next to the padlock.

Tip
To change from a portrait to a landscape orientation or vice versa, make sure the ratio is locked, then drag a corner off at a 45-degree angle and the orientation will flip. It's a little awkward initially, but becomes natural quickly.

Straighten

After you have selected the Crop tool you can access the Straighten tool and the Straighten slider. Click on the Straighten tool and click and drag along something in the image that you want to be level. Let go of the mouse button, and a new crop and rotation will appear. Press Enter or Return to apply the crop. Or use the Straighten slider by dragging the slider to quickly rotate the image.

Note
When using the Straighten tool you can click and drag along a vertical or horizontal line.

Straighten Shortcut

To speed up the process of straightening or leveling an image, press the R key to select the Crop tool. Next, press Control + (Windows) or Command + (Mac) and click and drag along something in the image that should be straight or level. This way you will never have to click on the Straighten tool in the panel. For even more help straightening the image, press Alt (Windows) or Option (Mac) while you use the Straighten tool; this will display a grid that will help you straighten the image. Finally, press Enter or Return to apply the straightening.

#66 Modifying Lens Correction

In photography, vignetting, which makes the corners of an image dark, is the result of a lens defect. This typically occurs with wide-angle lenses. The Lens Correction controls were created to help fix the corners, but you will quickly discover that the controls can also be used to create a unique aesthetic—the tool has evolved to be about both form and function. To take advantage of this valuable tool, open the Vignetting panel in the Develop module (**Figure 66a**).

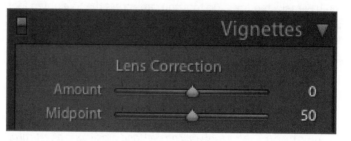

Figure 66a The Lens Correction controls provide you with a quick and easy technique for fixing lens vignetting or for simply darkening or brightening the corners for creative purposes.

Let's take a look at the sliders and an example to understand how the Lens Correction controls work. The Amount slider controls the overall type and intensity of vignetting. Drag the slider to the left to darken the corners, and drag the slider to the right to brighten them. The Midpoint slider controls how far from the corners the corner effect extends. Drag the slider to the left to extend the effect toward the center of the image, or drag the slider to the right to limit the effect to the corners. After applying lens correction it is typically best to go back to the Basic panel and make any final tone adjustments.

To fully understand how the Lens Correction controls work, just for fun let's look at a photograph a friend took of me surfing (**Figure 66b**). In this image the Amount slider was decreased to –100 in order to darken the corners. The Midpoint slider was increased to 85 to limit the effect to the corners. Next, in the Basic panel the overall contrast was increased slightly.

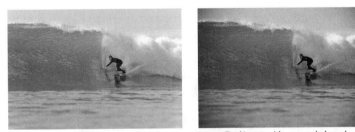

Original Final image with corners darkened

Figure 66b The viewer is typically attracted to areas of brightness in a photograph. With the Lens Correction controls you can darken the corners to focus attention on the subject matter. The corrections change the overall tone and mood of the image.

Note

The Lens Correction controls do not work very well on the edges of an image after it's been cropped. For a good way to get a vignetting effect on a cropped image, see Technique #67.

#67 Post-Crop Effects

The Post-Crop controls in Lightroom 2 were created in response to photographers who wanted to apply vignetting effects to their images after they have been cropped. The Lens Correction controls work only on the original edges, rather than the cropped edges, so for creative cropped vignetting, they have always worked poorly. Adobe not only responded to this shortcoming, but gave us even more in a set of creative and versatile new controls that I plan to use on a regular basis.

The Post-Crop controls are in the Vignettes panel in the Develop module (**Figure 67a**). First, let's take a look at what each slider does:

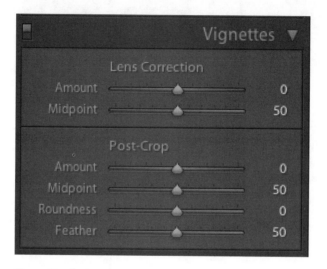

Figure 67a The Post-Crop controls in the Vignettes panel.

Amount – Drag the slider to the left to darken corners and to the right to brighten corners.

Midpoint – Drag the slider to the left to extend the effect toward the center of the image. Drag the slider to the right to limit the effect to the corners of the image.

Roundness – Drag the slider to the left to make the corner edges more oval. Drag the slider to the right to make the corner edges more circular.

Develop Module—Specialized Adjustments

Feather – Drag the slider to the left to remove feathering (softening) and to create a more distinct edge. Drag the slider to the right to increase feathering and to create a larger area of transition.

Once you have applied a crop to the image (**Figure 67b**), modify the sliders for a wide range of effects (**Figure 67c**).

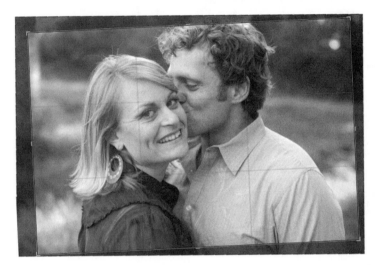

Figure 67b The cropped area of the image.

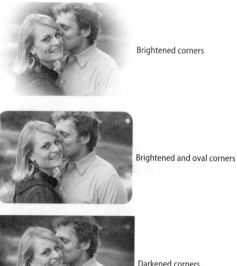

Brightened corners

Brightened and oval corners

Darkened corners

Figure 67c The Post-Crop controls let you apply creative vignetting and edge effects to the cropped area of an image.

Note
While the name Post-Crop implies that you need to crop the image, this isn't the case. You can apply these settings to your photos, with or without cropping them.

#68 Camera Calibration

Establishing a workflow to achieve a high level of precision and accurate color can be a bit tricky. Camera models made by different manufacturers record color in subtle yet different ways, so any one set of controls in Lightroom won't work the same for everyone. That being said, the majority of users will not need to go through the camera calibration process, as Lightroom does a phenomenal job with color. However, sometimes it's a good idea to use this advanced camera calibration process to achieve even more accurate color.

The controls in the Camera Calibration panel (**Figure 68**) can be used to modify how Lightroom interprets and displays the colors specific to your camera. Photograph a standard color target under the lighting you want to calibrate and then set the controls in the Camera Calibration panel. Next, save the adjustments as a Develop preset (see Technique #47). Then you can apply this preset to photographs that were taken in similar lighting conditions.

Figure 68 The Camera Calibration panel provides specialized controls to help specify how your camera works with color.

Let's take a look at the options to learn how to use the controls:

Profile – The Profile sets the version of the camera profile to use with your particular camera. Lightroom is equipped with various camera profiles that Adobe created after testing an extensive number of digital cameras. ACR 3.0 and higher are the newer and more improved profiles. The Profile ACR option that has the highest number is the most current profile. Choosing the highest number will give you the

Existing Embedded Profile

If the Profile reads Embedded, this reveals that the current photo already has an embedded profile. This is common with the following files types: TIFF, JPEG, PSD, or DNG.

Camera Calibration Creativity

The Camera Calibration controls were intended to help achieve more accurate color, but they can also be used to create unique color effects. If you haven't experimented with the sliders, give it a try with one of your images. They provide an avenue for making color changes that would be difficult to achieve any other way.

most current profile, but you may find that it makes the image appear different. In that case, try an older profile to maintain consistency with legacy photos.

Shadows – The Shadows slider allows you to correct for a green or magenta tint in the dark shadow areas of the photo.

Red Primary, Green Primary, and Blue Primary – This next set of controls allow you to adjust the color (Hue) and the color intensity (Saturation). Typically, it is best to modify the Hue and then dial in the Saturation. Moving the sliders to the left equals a negative or decrease in value, moving to the right equals a positive or increase in value.

CHAPTER ELEVEN

Develop Module—Adjustment Brush

One of the many advantages of working in Lightroom is the raw-processing digital imaging tool. What this means is that all of the adjustments are nondestructive (i.e., they can be undone at any point), and that the file size doesn't increase as you make adjustments. Until now, raw processing was limited to making adjustments to the entire image or to specific areas of tone or color. This has changed with the introduction of the Adjustment Brush tool, which is the most exciting new feature in Lightroom 2.

The Adjustment Brush tool is intelligent, nimble, lightweight, and strong. While brush tools have been used in Photoshop for a long time, the Lightroom Adjustment Brush tool is different. The brush makes adjustments without layers that are 100 percent nondestructive and do not significantly increase the image's file size. The Adjustment Brush tool now simplifies the digital photographic workflow so you can do more in Lightroom and less in other applications. The end result empowers photographers to make technical corrections and creative enhancements even more quickly. I'm excited about the Adjustment Brush tool, and once you use it, you will share this excitement.

In this chapter, we will first examine how the Brush Adjustment tool works. Next, we will apply it in a few scenarios to understand how it's used, particularly with dodging and burning, sharpening selectively, and improving eyes and skin on subjects.

#69 Introducing the Adjustment Brush Panel

The Adjustment Brush tool (**Figure 69a**), found below the Histogram in the tool strip, can be used to selectively "paint" a wide range of adjustments into specific areas. This allows you to make even subtler image corrections, enhancements, and creative modifications. To open the Adjustment Brush panel (**Figure 69b**), click the tool icon or press the K key.

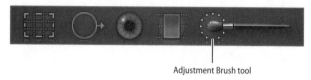

Adjustment Brush tool

Figure 69a Click on the Adjustment Brush tool to toggle open/close the tool panel.

Figure 69b The Adjustment Brush panel is divided into sections—Mask, Paint, and Brush. Below the sections is a set of options to control the overall effects.

The Adjustment Brush dialog may be a bit confusing, so let's examine it from the top down:

- **Mask** is the first set of options to work on current adjustments or create new ones. Choose New to create a new adjustment or choose Edit to change the Effect sliders or buttons to modify the current adjustment.

- **Effect** options determine what type of correction to apply. This will be "painted" onto the image. Click the Custom button to open the Adjustment preset menu. Here you can select a preset or save the settings as

Develop Module—Adjustment Brush

a new preset to create your own custom preset. To the right of the preset button is the toggle button, which allows you to alternate between the Effect sliders and the Effect buttons. The sliders function similarly to the rest of the Lightroom sliders. Drag to the right to increase the effect and to the left to decrease the effect. The buttons allow you to make incremental changes.

- **Brush** settings control how the brush functions. Click on A or B to select a brush. You are able to store two (A or B) different brushes with different settings. In addition, you can choose Erase to change the functionality and remove the effect. Once you have chosen A, B, or Erase, you can use the sliders to control different aspects of the brush. The Size slider controls the overall size. The Feather slider controls the hardness (low value) or softness (high value) of the brush edge. The Flow slider controls how quickly the effect is applied. Density controls the overall intensity of the effect.

- **The final set of options** controls the overall effects of the Adjustment Brush tool. Click on the toggle button to enable/disable the adjustment. Click Reset to undo and remove all of the adjustments. Finally, click close to close the panel.

Tip
Pressing O will show the mask when you're painting, while Shift + O will change the color of the mask.

#70 Learning the Brush Settings

Because the Adjustment Brush tool is so important to Lightroom, it is worth learning a few specifics about the brush settings. For starters, the size of the brush you use will determine how specific or broad the adjustment is. You can change the brush size with the same shortcut used in Photoshop: Press the [(left bracket key) to decrease the brush size, and Press the] (right bracket key) to increase the brush size.

The Feather slider controls the hardness (negative value) or softness (positive value) of the brush (**Figure 70a**). In most situations, you want a soft-edged brush in order to smooth out the transition between the areas where the effect is applied so it blends into the image. If you are working on an image with exact lines and shapes, like in architecture photography, a hard-edged brush may work best. To change the softness, use the slider or press Shift + [to decrease and Shift +] to increase the feather amounts.

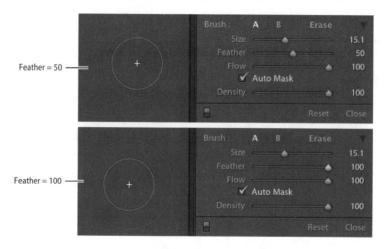

Figure 70a Increase the Feather amount to make adjustments that have smoother transitions.

The Flow amount can be likened to the amount of paint that flows from an airbrush. If the Flow slider value is low, say 10, one brush stroke will create a small effect. To build up the effect to 100 percent, with an airbrush you would need to use numerous back-and-forth brush strokes.

The Auto Mask option delivers the real magic of the Adjustment Brush tool. Turn this option on to make the brush intelligently limit an

adjustment to a specific area. Lightroom analyzes the image content, tonality, and color and looks for areas of similarity and difference. Then it attempts to constrain the effect to areas that are similar to where you first began to paint. In other words, Auto Mask detects edges in tonality and color, and uses this information to prevent the current effect from bleeding into unwanted areas. Turn this option off if you want the adjustment applied regardless of image content (**Figure 70b**).

The Density slider allows you to modify the overall intensity of the effects. This slider allows you to dial back the intensity of an adjustment that is made up of the adjustments of multiple effect sliders. Rather than having to change the amount of each effect slider, you can control them all with Density.

Tip

Here's another Erase tip, courtesy of Thomas Knoll (the software engineer who, along with his brother, helped develop Photoshop): Set the Density to 0 and it becomes an erase brush with otherwise identical settings to the original brush.

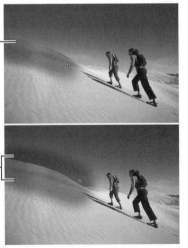

Auto Mask on — limits darkening to the sand dune

Auto Mask off — darkening is applied to the sand dune and the sky

Figure 70b The same single brush stroke is applied to both images, one with Auto Mask turned on and the other with Auto Mask turned off. The advantage of Auto Mask is obvious: It allows you to limit a painted effect to a specific area (image courtesy of Patitucci Photo).

Erase with Ease

To quickly erase any adjustment you've made, press Alt (Windows) or Option (Mac) to change the brush into an eraser. When you have finished erasing let go of Alt (Windows) or Option (Mac) to continue to add or paint the adjustment.

Go with the Flow

Regulating the Adjustment Brush tool flow lets you change how much of the effect is painted in one brush stroke. Because photographs typically have a wide range of tones and colors, you will find it necessary to change the flow amount based on the area of the image you are working on. To quickly change the flow of the painting, use the slider or else press 0–9 to change the Flow amount (1= 10 percent, 2=20 percent, and 0= 100 percent).

#71 Dodging and Burning

Dodging and burning are the traditional darkroom techniques used to brighten (dodge) and darken (burn) a photograph. Dodging and burning have helped traditional photographers create stunning photographs, and in the digital context we can do even more. In Lightroom, you can use the Adjustment Brush tool to dodge and burn. Here is an example of how to begin working on your own images.

First, let's brighten (dodge) a specific area of an image to enhance the overall tonal variety. Press K or select the Adjustment Brush from the tool strip. Next, it typically works best to increase the Exposure and Brightness amounts slightly, although the specific settings will vary from image to image. Choose a moderate-to-high Feather amount and a low Flow amount. Next, increase the Contrast and Clarity sliders slightly to add a bit of "snap" to the areas that will be brightened (**Figure 71a**). Finally, if you are going to brighten a distinct area of the image, select Auto Mask. Now that the Adjustment Brush tool controls are set, paint back and forth over the area that needs brightening.

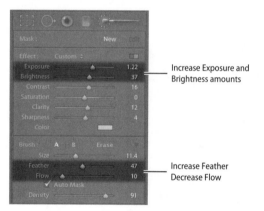

Increase Exposure and Brightness amounts

Increase Feather Decrease Flow

Figure 71a Use the Adjustment Brush tool to brighten or darken specific areas of the image.

In order to darken (burn) a specific area of an image follow the same steps as described above, except when setting the controls for the brush, be sure to *lower* the Exposure and Brightness amounts slightly. The final result is an image that is much more visually appealing (**Figure 71b**).

Before dodging and burning

After dodging and burning

Sky and grass darkened

Path brightened

Figure 71b The results of dodging and burning speak for themselves, adding increased tonal variety that brings new clarity and emotion to the image.

Tip
When setting the brush options, keep in mind that the best brightening typically results from choosing a low flow amount so that you can naturally "build up" the brightness.

The Art of Dodging and Burning

John Sexton, a renowned black-and-white photographer who once worked full-time with Ansel Adams, recently gave a presentation to the photography students at the school where I teach. To communicate the importance of the darkroom, he used some of Adams' most famous photographs, showing the difference between a print made with dodging and burning and another made without. The images without dodging and burning were dull and uninteresting. The images that Ansel Adams had dodged and burned were jaw dropping. This demonstration reminded me of the importance of dodging and burning in both traditional and digital photography.

#72 Selective Sharpening

When viewers look at an image, they are irresistibly attracted to areas of sharpness. Photographers use focus or sharpening techniques to direct the viewer to various aspects of a scene. For example, it is common to photograph people so that they are in focus and the background is blurry, so the viewer's attention stays on the person. Photographers revel in their ability to selectively draw the viewer's attention to specific subject matter.

When it's time to sharpen the image in postproduction, the sharpening must be applied in a way that honors the important part of the image. In the example below, the faces of my wife and of my daughter Annika are sharp—while their bodies and the background are soft (**Figure 72a**). The effect communicates how I feel about them and helps illuminate their expressions.

Figure 72a To capture this photograph, I chose an f-stop with a shallow depth of field to keep my wife and daughter in focus. I used the Adjustment Brush tool and painted extra sharpness and clarity onto the faces in postproduction.

To sharpen a particular area of an image, press K or select the Adjustment Brush tool from the tool strip. Increase the Clarity and Sharpness sliders. The actual amount of clarity and sharpness needed will depend on the image quality and its resolution. (With the image in Figure 72a, I

chose clarity of 22 and sharpening of 60; see **Figure 72b**.) Choose a brush size that is smaller than the area you are sharpening. Next, increase the feather amount so that the sharpening blends seamlessly into the non-sharpened areas. Finally, choose a low amount for the flow so that you can build up the sharpening slowly. In this way you will minimize your chances of over-sharpening the image. Now that the controls are set, zoom to 100 percent and paint back and forth on the areas that need to be sharpened until the images looks good.

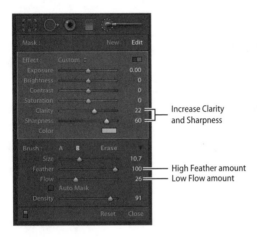

Figure 72b It typically works best to slightly increase the Clarity and Sharpness amounts and use high Feather and low Flow amounts.

#73 Improving Eyes

Photographs that offer eye contact between viewer and subject have wide appeal and high impact, so learning how to enhance eyes is an important skill. To improve the appearance of eyes, you will want to use multiple Adjustment Brush tool applications (see the close-up detail, **Figure 73a** and **Figure 73b**).

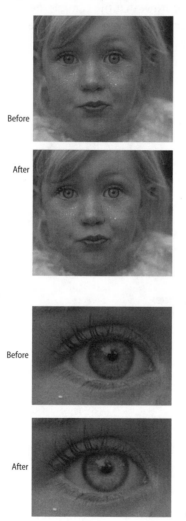

Before

After

Figure 73a To evaluate the eye for needed enhancements, it is worthwhile to zoom out to examine the entire photograph.

Before

After

Figure 73b The before-and-after details reveal the effect of improving the eye.

First, press K or select the Adjustment Brush tool from the tool strip. Next, follow the steps below:

Brush Application #1 – For the first brush application, focus on brightening, sharpening, and increasing the color in the iris. Actual settings for each image will vary, but it is typically best to increase all the effects: Exposure, Brightness, Contrast, Saturation, Clarity, and Sharpness. Next, choose a brush size small enough to paint only on the iris and not the pupil. Increase the Feather amount and decrease the Flow so that you can build up the effect slowly (**Figure 73c**).

Figure 73c Use the Adjustment Brush tool with these settings to increase the overall brightness, sharpness, and color of the iris.

Now that the brush is set, begin to paint on the iris with multiple brush strokes. The area of the iris that should be the brightest and sharpest is the area opposite the light source. In the example, the light source is the sky above, so the bottom area of the iris is brightest and sharpest.

Brush Application #2 – For the second brush application, aim to subtly darken the outer edge of the iris. This will give the eye more shape and dimension. Lower the Exposure and Brightness while slightly

The Importance of Eyes

The first song my wife and I ever danced to was "In Your Eyes" by Peter Gabriel. At the time we were teenagers. Now, 18 years later, those song lyrics ring true, "In your eyes, I see the light and the heat. In your eyes, I am complete." There is something powerful about eye contact, especially in photography.

Sharpest Eyes Tip

The next time you photograph a person make sure the eyes are not only sharp, but the sharpest element of the image, while other elements of the image like the background are out of focus.

increasing the Contrast, Clarity, and Sharpness (**Figure 73d**). Choose a very small brush size that will match the size of the iris edge. Increase the Feather and decrease the Flow amounts. Begin to paint on the iris edge with multiple brush strokes slowly building up the effect.

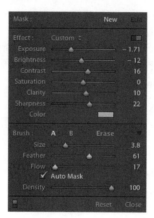

Figure 73d To add more shape to the eyes, use the Adjustment Brush tool with these settings to darken the outer edge of the iris.

Tip

In Lightroom you use one Adjustment Brush tool to accomplish multiple tasks like sharpening, brightening, and enhancing color. In Photoshop you would need to use multiple layers and create multiple adjustments. Improving eyes in Lightroom is much faster!

Tip

To learn more about retouching portraits, do a quick Google search for "chris orwig retouching."

#74 Softening Skin

The Adjustment Brush tool allows you to make specific corrections and enhancements to areas of your image. The brush was created around the features that photographers use most to quickly "paint in" effects. One of these effects is skin softening, and the Adjustment Brush tool now has a built-in preset to make it happen.

To soften, select the retouching brush from the tool strip or press the K key. Click on the Effect pop-up menu and choose Soften Skin (**Figure 74a**). This will lower the Clarity amount to –100 and increase the Sharpening amount to 25. Think of these numbers as a good starting point. The actual amount you use will depend on the image quality, the lighting conditions (hard light sources will require more softening than soft, diffused light sources), and the amount and variation of skin texture. Next, choose a small brush size—I find that a brush about the size of the entire eye works well. Increase the Feather amount to 100. Decrease the Flow amount to somewhere between 10 and 30.

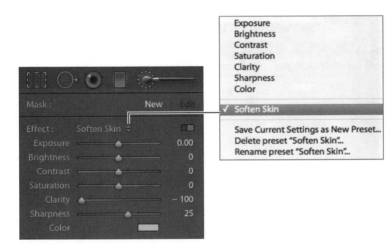

Figure 74a The Adjustment Brush tool now includes a built-in skin-softening effect option.

How much smoothing to
apply? Consider the context.
If you are working in photo-
journalism, you cannot take
much (if any) creative license.
But if you are, for instance,
writing poetry, it is essen-
tial to take creative license.
Your genre should direct the
amount of retouching that is
appropriate.

Why Smooth Skin?

Apart from the fact that our
culture, for good or for ill,
values unblemished skin,
there are other reasons that
skin smoothing may help
improve your photographs.
Human skin contains an
incredible amount of tone
and texture variation. When
you talk with someone you
don't notice the variation
because the person moves,
smiles, frowns, etc. In a
close-up picture you notice
all that was unnoticeable in
real life. The still image acts
as a magnifying glass. So you
make an image "real" to our
visual perception by slightly
improving the skin.

With the brush controls set, paint back and forth over the areas of skin
that need to be smoothed. Don't overdo the effect or you will have an
unnatural look that detracts from the overall image (**Figure 74b**).

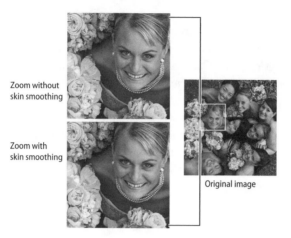

Zoom without
skin smoothing

Zoom with
skin smoothing

Original image

Figure 74b The best skin-softening results are subtle. Over-softening will
draw the viewer's attention to the retouching rather than the subject.

Develop Module—Adjustment Brush

CHAPTER TWELVE

Develop Module—
Image Cleanup

A photography instructor I know is constantly encouraging his students to "reduce and simplify" their photographs. He backs up his message by showing hundreds of amazing, simple, clean, and powerful photographs.

He tells the students to clean up their images in-camera by looking through the viewfinder at the subject and then turning away from the subject and inspecting around the edges of the frame for potential problems.

In spite of your best efforts, distractions and blemishes will show up in your images. You need to learn how to quickly and seamlessly remove blemishes in postproduction. Remember—reduce and simplify!

In this chapter we will examine a few tools to help you simplify and clean up your images. We'll learn how to use the Spot Removal and Red Eye Correction tools.

Before we start, remember that one of the main advantages of using Lightroom for image cleanup is that it is completely nondestructive and can be undone at anytime. Once you get the hang of it, you can actually retouch more quickly. And because the improvements don't increase file size, there is no lost time waiting for a larger file to save. That little bit of time that you save on each image really adds up.

#75 Reducing Small Blemishes

One of the distinguishing characteristics of professional photographers is the amount of time they spend attending to small details. In this technique, we learn how to use the Spot Removal tool to deal with the small detail of minor blemishes in photographs.

To use the Spot Removal tool, navigate to the Develop module and then choose View > Spot Removal. Or click on the tool in the tool strip (**Figure 75a**), or press the N key. Next, choose either Clone or Heal. Typically, Heal will work best, as it blends in the retouching and makes it less noticeable. First try Heal, and if that doesn't work, try Clone. Under Brush, choose levels for Size and Opacity. If you are using the Heal option, which has built-in blending, it works best to use an opacity of 100.

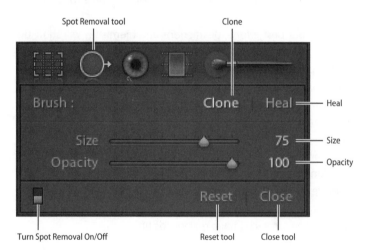

Figure 75a Reach for the Spot Removal tool to clean up blemishes or distractions in your photos.

Next, click on the blemish to select the area of the image to be fixed. When you do this Lightroom will automatically analyze the image and choose a sample area. If you would like to select the sample area yourself, click and drag. Work your way through the image, removing the small blemishes. White circles will appear around the areas that have been retouched (**Figure 75b**). To toggle on/off the visibility of the white circles, press the H key.

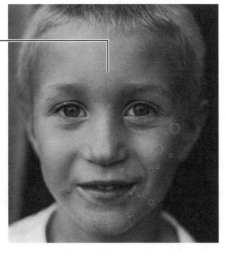

Selected circle

Sample

Spot

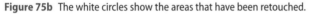

Figure 75b The white circles show the areas that have been retouched.

To change the size or position of the sampled or selected area, click on one of the circles. The circle you have clicked on will become thicker. Next, hover over the circle edge, and the cursor will change in appearance to a line with two arrows. Click and drag to increase or decrease the circle. Or hover over the circle, then click and drag to reposition. To delete a retouched area, click and press Delete or Backspace. If you have taken the time with the Spot Removal tool, the results will speak for themselves (**Figure 75c**).

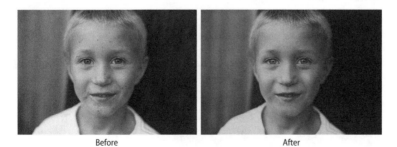

Before After

Figure 75c The final result is a clean, simple, and compelling photograph.

Tip

You can change the Spot Removal tool size by pressing the bracket keys. Press [to decrease the size and] to increase the size.

Blemishes and Believability

Photographer Rodney Smith once told me that rather than retouch everything, he liked to leave blemishes in his images. Blemishes made his images more authentic, more believable, and more human. Keep this in mind as you retouch your own images. You don't need to remove all the blemishes, just the ones that detract from the intent of the photograph.

Clone or Heal?

The Spot Removal tool is actually two tools in one— Clone and Heal. Choose Clone to apply the actual sampled area to the selected area. (Clone automatically feathers the sampled area.) Choose Heal to blend the texture, lighting, and shading of the sampled area into the selected area.

#76 Removing Repetitive Blemishes

In the previous technique, you learned how to remove spots that are specific to one particular image. Sooner or later you will need to remove blemishes created by a piece of dust or dirt that is on the camera lens or sensor. While discovering a repetitive blemish on a set of images can be frustrating (**Figure 76a**), you can use the Spot Removal tool to quickly fix all the images.

Three exposures with a blemish in the same location

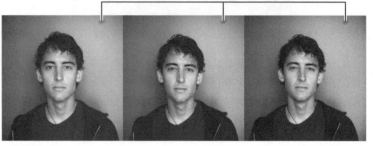

Figure 76a In these three different portraits, the blemish in the top right corner is the result of a piece dust on the lens.

Navigate to the Develop module and select the Spot Removal tool by choosing View > Spot Removal. Click on the tool in the tool strip or press the N key. Next, choose Heal. Choose an Opacity setting of 100. Position the cursor over the blemish and change the brush size so that it is bigger than the blemish (**Figure 76b**). Click and drag to select the sample area. Look for a sample area that has tone and texture that are similar to the blemished area.

Figure 76b To successfully remove a blemish make sure the brush size is bigger than the blemish.

Next, in the Filmstrip select all of the images needing to be fixed. Click on the first image and then hold down the shift key and click on the last image (**Figure 76c**). Now you are ready to press the Sync button (**Figure 76d**), which will open the Synchronize Settings dialog. Make sure only the Spot Removal section is ticked. Click OK in the dialog so that all of the images will be healed. Finally, navigate through the set of images to make sure that the blemish was successfully removed. If the blemish was not completely removed from any of the images, try moving the sampled area circle by hovering over it and dragging it to a new position.

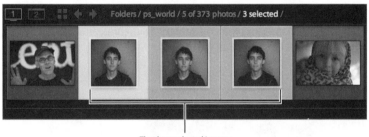

The three selected images

Figure 76c Select all of the blemished images in the Filmstrip.

The Sync button

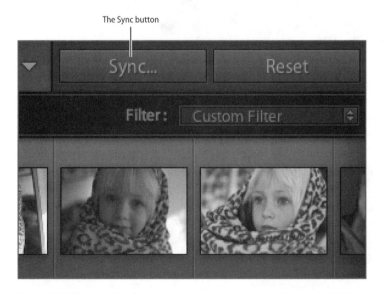

Figure 76d Press the Sync button to synchronize or to copy and paste the Heal setting onto the entire set of the images.

#77 Reducing Red Eye

While many cameras have built in red-eye reduction technology, the problem still happens in everyone's photos. As a result, it's helpful to know that there is a quick and easy fix with the Red Eye Correction tool.

To use the Red Eye Correction tool choose View > Red Eye or click on the red-eye icon in the tool strip (**Figure 77a**). Next, position the cursor over the red pupil (**Figure 77b**). It is typically best to select the entire eye, not just the pupil. If the current tool size is big enough, click the center of the eye to use the current size. Or press the [] keys to change the tool size. Press [to decrease the size, and] to increase the size. In addition, you can click and drag from the center of the eye to change the size as well.

If the red was not completely removed, drag the Pupil slider to increase the red removal area, or try increasing the Darkening amount to create a deeper black.

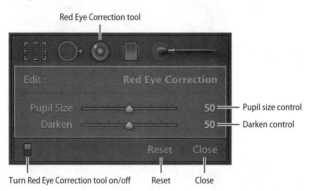

Red Eye Correction tool

Edit : Red Eye Correction

Pupil Size 50 — Pupil size control

Darken 50 — Darken control

Reset Close

Turn Red Eye Correction tool on/off Reset Close

Figure 77a Use the Red Eye Correction tool to quickly correct the pupil so that it is black.

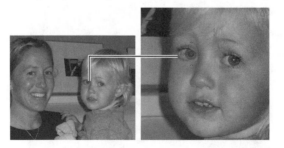

Figure 77b Position the cursor over the eye and click to apply the correction. A white circle will appear around the eye. To hide or show the circle, press the H key.

CHAPTER THIRTEEN

Develop Module— The Graduated Filter

The digital equivalent of a traditional photographic tool—the graduated filter—is now a part of Lightroom 2. This tool provides photographers with a unique way to make image corrections and enhancements. Using a wide range of controls, from Exposure to Sharpness, you can apply an effect that has a distinct starting point and then eventually fades or trails off. In addition, you can control where and how quickly the effect fades, which allows you to make improvements that blend seamlessly into the photo without any telltale signs.

The Graduated Filter tool helps creatively solve problems that photographers have been grappling with for ages (see sidebar "The Graduated Filter in Context"). This new tool does require a shift in thinking as it enables you to manipulate effects and to accomplish results that were previously limited to other software or to in-camera solutions.

This short chapter will help get you up to speed on this topic and show you with two specific examples how to use this tool. While the tool offers almost innumerable uses, the intent here is to show you how it works and to lead you to think about new ways to improve your own images.

#78 Introducing the Graduated Filter

The Graduated Filter in Context

By understanding how traditional graduated filters function, we can better understand how to use them in Lightroom. In fact, nothing compares to the tonal range that the human eye can see—from bright to dark—and that cameras (digital or film) are unable to record. There have been many creative attempts to overcome this challenge. For example, digital landscape photographers often make one exposure for the land and another for the sky and then combine the two exposures in postproduction. Another technique is to use a graduated filter or a split neutral-density filter directly on the camera lens. These filters work like the shading at the top of a car windshield, where an increased density blocks the brightest light from the sky and the less-dense lower windshield section lets the driver view the road. On-camera, a graduated filter blocks light in one area (the sky) and lets light through in another area (the land). The final result is correct exposure for both areas.

The Graduated Filter tool lets you make adjustments to your images within Lightroom that were previously impossible. You can create a gradiated correction or enhancement made up of Exposure, Brightness, Contrast, Saturation, Clarity, Sharpness, or Color.

To Select the Graduated Filter tool, just click on it in the tool strip (**Figure 78a**), or choose View > Graduated Filter, or press M. Next, choose an Effect, or modify the Effect slider controls. Now that the tool is set, click on the area where you would like to use the effect. Continue to hold the mouse button down and drag away from the initial area that was clicked. Drag farther away to create more of a gradiated and fading transition. Drag less to create less of a transition. Drag and rotate in order to rotate the direction of the transition.

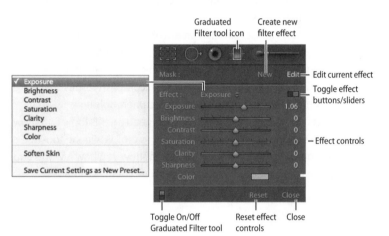

Figure 78a Use the Graduated Filter tool to apply an effect that gradually fades away and blends seamlessly into the image.

As you drag, notice the effect, the effect guides, and a small node (called a pin). The lines reveal where the effect occurs and the length of the transition (**Figure 78b**). Position the cursor next to the pin, and the cursor will changed into a bent line with an arrow on each end. When you see this new cursor, click and drag in order to rotate the effect. Position the cursor over the pin, and the cursor will change into a hand icon. With the hand icon visible, click

and drag to reposition the effect. If you would like to make changes to the controls, simply modify the sliders. Finally, if for some reason the effect is undesirable, press the Delete or the Backspace key to delete the effect.

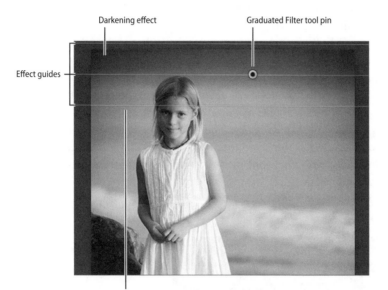

Darkening effect Graduated Filter tool pin

Effect guides

Darkening effect gradually fades to this guide

Figure 78b The Graduated Filter tool pin and effect guides help you see the area that is affected.

Tip
If you find the Graduated Filter tool pins and effect guides to be distracting, simply toggle the H key to hide or show those elements.

Tip
For more creative results, you can add multiple Graduated Filter tool adjustments to one image. To create another adjustment click the New button and then go through the steps described above.

Tip
To keep the Graduated Filter tool brush stroke in a straight line hold Shift while you paint in the effect.

#79 Darkening the Sky

One of the most common uses for the Graduated Filter tool is to correct an image when the subject is correctly exposed but sky in the background is overexposed. (This is how traditional film photographers use a graduated filter on a camera lens and where the idea for the building a digital version of the filter originated.)

To darken the sky, select the Graduated Filter tool. Click on it in the tool strip, choose View > Graduated Filter, or press the M key. Next, modify the controls to darken and increase the contrast of the sky (**Figure 79a**). While the actual settings will depend on the brightness of the sky, try these example amounts as a starting point. Most important, lower the Exposure significantly. Finally, slightly lower the Brightness. Increase the Contrast, Clarity, and Sharpness. Keep in mind that if these control settings don't work with your image you can always change them after you have applied the tool.

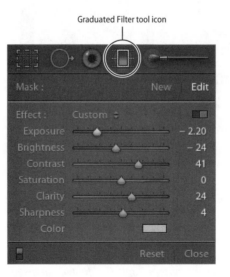

Graduated Filter tool icon

Figure 79a Click on the Graduated Filter tool icon to toggle open/close the tool panel.

Now that the controls are set, click on the area of the photo where you would like the effect to occur. With the examples below, I have clicked above the horizon and dragged down (**Figure 79b**). Next, continue to press the mouse button and drag to increase the transition or fade of the effect. Click and drag farther away from the initially clicked area to increase the transition. Click and drag less distance to shorten the transition. Or click, drag, and rotate to change the gradient direction, as was done in the example on the left.

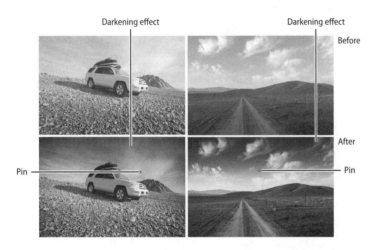

Figure 79b The best way to understand how the Graduated Filter tool works is to look at the final results. Here the sky becomes darker near the tops of the images.

#80 Shifting Focus

In this brief technique, we'll look at how the Graduated Filter tool can be used to creatively shift the focus of an image. To Select the Graduated Filter tool, click on it in the Tool Strip, or choose View > Graduated Filter, or press the M key. Next, decrease the Clarity and Sharpening amounts (**Figure 80a**).

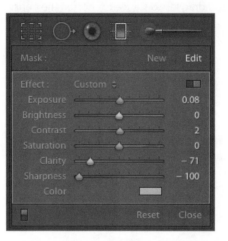

Figure 80a Strongly decrease the Sharpening and Clarity in order to create the desired effect in this image. Of course, the actual amounts will depend upon the desired focus of your image.

In the example below, I photographed Nick Dekker, black-and-white photographer and master printer. I enjoy Nick's photography and vision, so I wanted to use on-camera focus to create a film image that emphasized his eyes. After I developed the film and opened the image in Lightroom, I decided to shift the focus even further, by making his shirt and beard more out of focus. I used the settings described above, so I clicked

Hocus Focus

The eye is attracted to areas of focus, but sometime photographers go overboard and want everything in focus. This can work, but usually leads to images in which the viewer doesn't know where to look. Better to use unfocused or out-of-focus areas of the image to create impact on the focused areas—less focus to create more focus. And here's where the magic of less with more actually happens.

above the button on his shirt and dragged up. The final result is an image that communicates my visual intent even more strongly than the unenhanced photo did (**Figure 80b**).

Figure 80b Using the Graduate filter tool to decrease (or blur) the focus on the shirt, I was able to make the eyes and the face appear more in focus.

Tip
Shifting focus (decreasing the sharpening and clarity of an area of an image) typically works best when you apply the effect to an area that isn't completely sharp to begin with.

Focus Inspiration

If the idea of shifting focus is new to you, here are a couple of places you can look for inspiration. Visit www.lensbabies.com and click on the gallery section to learn about the Lensbaby lens, which creates a uniquely focused image. Or try doing a Google image search for large-format photography. Unlike typical users of 35mm cameras, large-format photographers tend to create beautiful images with a distinct focus.

Slideshow Module

Years ago I watched one of my favorite photographers present his work in a slideshow using a slide projector. There was the hum of the projector fan and his voice narrating a wonderful collection of images. In a darkened room, seeing his work come to life inspired me to create my own slideshows.

The presentation was dramatic, yet I knew that creating an analog slideshow was a tedious process of sequencing lots of mounted slides, keeping them clean, and keeping them in order. You had to insert every slide in the carousel one at a time, and if you wanted to add or remove a slide, which happened over and over, you had to reshuffle the entire carousel—an experience that these days few people miss!

That said, showing off your work in a slideshow format is still an invaluable aspect of the photographic experience, and Lightroom makes it a breeze. In this chapter, we'll look at how to create, customize, and share your work with interactive slideshows in the Slideshow module.

#**81** Interface and Shortcuts

In Lightroom, once you've learned some basic operating principles, you can apply them to all the different modules. So even if you've never used the Slideshow module before, you can get up and running with only a quick look at the options:

Slide Editor view is the large preview in the middle of your screen. It shows you an accurate, real-time preview of any adjustments you make to your slideshow.

Template Browser allows you to create a slideshow based on a template. Hover your cursor over the different templates to see the differences in the Preview panel (**Figure 81a**). To select a template click on the template name and it will appear in the Slide Editor view.

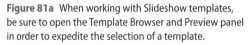

Figure 81a When working with Slideshow templates, be sure to open the Template Browser and Preview panel in order to expedite the selection of a template.

Options panels on the right side of the screen help you customize the layout of your slideshow as well as the playback options. We'll cover these panels in more detail in the next tip, Creating a Slideshow.

Text rotation and playback controls are found in the toolbar below the Slide Editor view (**Figure 81b**). These controls allow you to add text to your slides, rotate the text, start and stop your slideshow, and manually advance the slides.

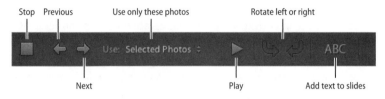

Figure 81b In the Slideshow module, use the toolbar controls to further customize the text and playback of your slideshow.

Tip
If you don't see the toolbar below the Slide Editor, press the letter T on your keyboard to toggle the toolbar on again.

Note that the Collections panel on the left and the Filmstrip at the bottom appear in all of the modules except the Develop module. This is important because it provides an easy way to choose which images will be a part of your slideshow without your always having to switch back to the Library module. If the Filmstrip isn't visible just press F6 on your keyboard to bring it back.

Now that you're familiar with the basics of the interface, it's time to create your first slideshow.

#82 Creating a Slideshow

You should start the process of creating a slideshow in the Library module because that's the easiest way to choose the images you want to include. Here you can select a variety of images, even images spanning multiple drives and folders. In the Library module, select the images you would like to use for your slideshow and then switch over to the Slideshow module.

Hover your cursor over the various template names in the Template Browser panel to see a preview in the Preview panel. When you find a template you like, click on its name to change your layout (**Figure 82a**). You'll learn more about customizing your layout in the next technique, but for now remember that every slideshow is based on a template, even if it is just the default template.

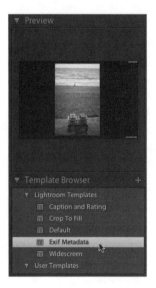

Figure 82a Hover your cursor over Slideshow template names for a quick preview.

To see an instant preview of your slideshow in the middle of your screen that includes layout, overlays, and slide duration, click the big Preview button on the right side of the screen. When you're ready for showtime, click the Play button, and the slideshow will take over your entire screen.

Another great way to create a slideshow is by selecting a smart collection that contains a dynamic set of your favorite images. For example, choose the Five Stars smart collection if you want to display your best

portfolio images, or choose the Recently Modified smart collection to share all the images that you've worked on in the last two days. With smart collections it's easy to show a group of images with common attributes instead of manually selecting images one at a time.

For even more control over which images are included you can choose the new Use pull-down menu in the toolbar (**Figure 82b**). This lets you easily control whether all the photos in the Filmstrip, just the selected photos within the Filmstrip, or just the flagged photos in the Filmstrip are included in the slideshow.

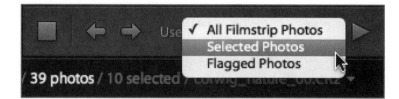

Figure 82b The Use menu lets you control which photos are included in your slideshow based on the photos that are selected or flagged.

Engaging with Your Audience

For a truly interactive slideshow, hand the keyboard over to your client or guest and let them forward the slides at their own pace with the left and right arrow keys. This way they can quickly pass over the images they aren't as interested in, or they can spend more time viewing their favorites.

#**83** Customizing Slideshow Settings

Customizing a slideshow lets you emphasize what's important to you when you present your images. As in other Lightroom modules, the panels on the right are sequenced from top to bottom on purpose, so let's work our way through the options.

Panel Options

Options panel – This panel includes basic settings for applying a stroke (border) and a drop shadow to each image in the slideshow. Any changes made in the panels on the right are not slide specific—they affect every slide in a slideshow.

Layout panel – Use the Layout panel to control the size and position of your images on each slide. If you want the margins on all four sides to match, make sure the Link All option is enabled. If you'd rather go for a more freeform approach, you can use your cursor to move the guides in the Slide editor.

Overlays panel – The three types of overlays you can add to a slideshow are your identity plate, your star ratings, and text overlays. With the Shadow controls at the bottom of the Overlays panel you can add a drop shadow that will affect all the overlays, regardless of type.

To add a text overlay to your slideshow, click the ABC button below the Slide Editor, choose from the pull-down menu the type of text you want to add, and the overlay will be added to the slide. For even more options, choose Edit from the text pull-down menu and you'll see the possibilities are virtually endless. You can add as many text overlays as you like.

Now you can use your cursor to move or scale the text, and you can even rotate the text with the text rotation icons in the toolbar (**Figure 83a**). Use the Color, Opacity, Font, and Face controls in the Overlays panel on the right to further customize each text overlay to your liking.

Figure 83a You can rotate your text overlays with these rotate left and rotate right icons in the toolbar.

To temporarily hide your text overlays without actually deleting them, just toggle the Text Overlays option in the Overlays panel. To delete a text overlay, select it in the Slide Editor and press the Delete key on your keyboard.

Backdrop panel – You can dramatically change the look of your slideshow by changing the background color of your slides, but I recommend keeping things simple so the emphasis is always on your images. One subtle way to add a bit of depth to your slides is to use the Color Wash option, which is a gradient effect that blends from your background color to your color wash color. Another way is to enable the Background Image option, drag an image from the Filmstrip, and use the Opacity slider to adjust the transparency of the image to a pleasing level.

Note:
The color wash and background image can mix together, so turn off the color wash if you want to see only the background image.

Titles Panel – The Titles panel is new for Lightroom 2 and adds a nice professional touch to the presentation of your images. You can enable an Intro Screen and Ending Screen in the color of your choice (black is a great choice) so that the experience fades up from black at the beginning and fades back to black at the end. For a dash of extra self-promotion, you can enable your custom identity plate to show at the beginning or end (or both) of your slideshows. In addition, you can change the identity plate for each screen to give useful information about the slideshow, or even add your Web site information at the end.

Playback Panel – This is where the action happens. Use the Playback panel to control slide duration, fade speed between slides, and whether your images should fade to a color between each slide. Using the fade color option might look funny if you're also using a colored background for your slides. But if your slideshow is just images with a solid background, then matching the background color and the fade color can add a nice cinematic effect. Last, you can also set your slideshow to present your images in a random order and to repeat, or loop, indefinitely.

When you have a second monitor, Lightroom will detect it and include an extra section called Playback Screen. It allows you to select which screen the slideshow plays on, and to choose whether to blank the other screens. Also, in the multi-monitor section in the Filmstrip there's an option to preview the second screen on the first screen. With this feature, if clients are looking at one screen, you can see what they see, and thus know where they are in the slideshow.

Saving Templates

After you've spent a lot of time customizing your slideshow design, you can save it as a template for future use with different sets of images. Just click the Plus (+) icon in the Template Browser panel on the left, give your template a memorable name, and save it in the User Templates folder or a new folder of your choice. Now you can apply all your custom settings with a single click instead of remembering and recreating all your choices. To delete a user template, select it in the Template Browser and click the Minus (-) icon.

If you have made a few tweaks to a slideshow design and you want to update an existing user template instead of creating a new one, just right-click (Windows) or Control-Click (Mac) on the name of your template and choose Update with Current Settings from the context menu.

Note
You cannot update the included Lightroom templates, only user templates.

Saving Output Creations

The ability to save a template is convenient, but the ability to save a complete custom slideshow, including which photos are in the slideshow, as an output creation is an incredibly useful technique. After you've chosen your images and customized your slideshow settings, click the arrow or

the plus (+) icon in the Collections panel to reveal the New Collection pull-down menu, and choose Create Slideshow (**Figure 83b**).

Figure 83b Save your slideshows as output creations for easy replay without having to re-create each slideshow from scratch.

In the Create Slideshow dialog you can give your output creation a name and save it into an existing collection set. You also get to decide if all images currently in the Filmstrip are included and whether or not to create new virtual copies just for this slideshow. Your new slideshow output creation is saved under the Collections tab and remembers all the images and all the settings for that presentation, making it really easy to use the same slideshow over and over again for different audiences.

#84 Adding Music to a Slideshow

Adding music to your slideshows is a great way to set a mood, tell a story, or impress a client. The method of adding music is slightly different between Macintosh and Windows, but getting your music files set up ahead of time will make the process pretty painless.

Macintosh Setup

If you're using a Mac, start by creating a playlist in iTunes that includes the songs you want in the order in which you want to hear them. After you've arranged your songs in iTunes, switch back to Lightroom and open the Playback panel in the Slideshow module (**Figure 84**). Now enable the Soundtrack option and choose your custom playlist. If you don't immediately see your new playlist, just choose the Refresh Playlist from iTunes command in the pop-up menu and then select your new playlist.

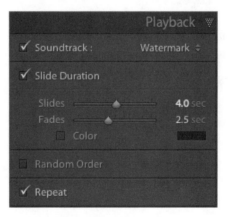

Figure 84 Add music files to your slideshows with the Playback panel.

Windows Setup

If you're using a Windows computer, start by organizing your music files in a folder and naming the files so that they're in the order you want to hear them. Next, switch back to Lightroom, open the Playback panel in the Slideshow module, and enable the Soundtrack option. Now click to choose the folder that contains your music files and you're ready to rock!

Time to Jam

To verify that you've selected the correct playlist or folder, click the Preview button and listen to the audio. If it's the right music that sets the appropriate tone, you're ready to jam. If you need to adjust the audio, just follow the steps outlined above until you get it right.

Note

For better or for worse, slideshow music only works when you play the slideshow within Lightroom. That means if you export the slideshow to an Adobe PDF (see next technique), the music won't be retained in the PDF.

#85 Exporting Slideshow as PDF

The Slideshow module is best suited for showing off your work on your own computer, but there are times when you'll want to export your slideshow to share it with others. Lightroom 2 lets you export your slideshow as either an Adobe PDF or as a sequence of JPEG files. The PDF option is the most portable and immersive experience, so let's start there and explore the options.

When you're ready to share your slideshow masterpiece, click the Export PDF button on the left side of the screen. The Export Slideshow to PDF dialog presents you with a handful of options (**Figure 85**).

Figure 85 Customize your PDF slideshow export options before distributing your work.

Quality Slider

After giving your PDF a unique name (Lightroom will automatically append the .pdf extension for you), your next step is to specify the JPEG compression to apply to your photos. I always want my images to look great, so I tend to keep this option turned up to at least 90. If you have a lot of images in your slideshow and the resultant PDF is too large, the easiest way to save file size is to drop down the quality a bit and export again.

Size Options

If you know the dimensions of your audience's display, choose the setting that matches from the Common Sizes pull-down menu or enter

the dimensions in the Width and Height fields. If the target display is your own computer, then choose the Screen option from the pull-down menu and Lightroom will detect your current monitor resolution and export a slideshow to match.

Automatically Show Full Screen

Adobe Acrobat and Adobe Reader offer a way to view PDF slideshows with a really slick full-screen viewing mode. Instead of relying on your viewers to know about this option, I suggest enabling this option on export so your audience will have a more immersive and compelling experience. Think of it as autopilot for your viewers because all they have to do is double-click the PDF document.

What's Missing?

Not all the custom slideshow settings from Lightroom can be retained in a PDF presentation. Specifically, the Playback options for soundtrack, slide transition speed, randomization, and looping are not preserved in the exported PDF because those attributes are controlled by the viewer's preferences in Adobe Acrobat or Adobe Reader. Despite these few exceptions, PDF is a great way to share your work because anybody with a computer has the free Adobe Reader software (and if they don't, the price is right) so they should be able to view your slideshow without needing any new software, plug-ins, or downloads.

Exporting to JPEG

The ability to export a slideshow as a sequence of JPEGs is a new addition to Lightroom 2 and a great way to prepare your creation for other presentation formats including DVD authoring, Flash animation, and so on. Click the Export JPEG button in the Slideshow module, choose the quality and size settings you need, and you'll have a folder full of JPEGs. You could then use the JPEGs to "rebuild" the slideshow in another software application like Adobe Flash or Adobe Premiere, to name a couple.

Print Module

As WWII photographer W. Eugene Smith once said, "Negatives are the notebooks, the jottings, the false starts. . . . A proper print is the only completed photograph." There is something special about a print. And the photographic process feels complete when you hold that print in your hands. It is easier for me to delete a digital file than to throw away a print. I'm sure you'd agree that printing is the most satisfying aspect of your workflow.

In this chapter we'll focus on the Print module and how to create stunning, high-quality prints. First, we'll learn about Print Collections and how to use print templates. Next, we'll discuss how to use the Contact Sheet/Grid Layout engines. Then we will dig into how to get the most out of Picture Packages. From there you will learn about adding Overlays to your print layouts. Finally, we will discuss how to use the Print Job panel to "complete" a photograph and create a stunning final print.

#86 Creating Print Collections

The majority of your organizational work takes place in the Library module, including creating collections. But you can also create collections in the Slideshow, Web, and Print modules. Why create a collection? Collections give you the ability to group photos in a way that is not contingent upon the folder structure or where the photo is actually saved.

The advantage of making a collection in the Print module is that you can create groups of photos based on your print needs. This is especially helpful because the photos you select to print are typically quite different from the photos grouped for other purposes. The photos that I select to print are the best of the best.

To create a print collection, navigate to the Print module. Next, select the photos in the Filmstrip that you want to add to the collection. Then, click on the plus (+) icon in the Collections panel and choose Create Print (**Figure 86**). Now, type a name for the collection and select the Include selected photos option. Finally, click Create.

Figure 86 When you create a Collection you can decide to include it in a Collection Set or simply leave it as a stand-alone.

Once you have created a print collection, a distinctive icon appears next to the collection name. This icon reveals where the collection was created, i.e., the Library, Print, Web, or Slideshow module, and also whether you will still be able to view, use, and access the Collection in the Library, Slideshow, and Web modules.

Export Collection as a Catalog

The images that you group to print are usually the best images of a set. They'd better be good if you are spending the time, energy, and resources to make prints. So you may want to export a print collection as a catalog. To do this, select the collection (or smart collection). Right-click (Windows) or Control-click (Mac) the collection name and choose Export This Collection As A Catalog. Next, specify the name and where you want to save the catalog. Finally, click Save.

#87 Using Print Templates

You will discover that creating prints and print layouts in Lightroom requires making prints at specific sizes or configurations over and over again. In these cases, using a predetermined template or creating your own template can dramatically increase your workflow productivity. For example, you could use the Print module template to create and print a contact sheet. Or you may simply want to use the print templates as a starting point to customize a layout to make unique print layouts.

To use a print template, select one or more photos in the Filmstrip. In the Print module, open the Preview and Template Browser panels (**Figure 87a**). Next, position your cursor over one of the Lightroom templates. As you hover over the different templates you will see the layout appear in the Preview panel above. When you have found the template that will work best, click on the template name to select it. Once you have selected the template, your image(s) will appear in the main window inside the selected layout (**Figure 87b**).

Figure 87a Open the Preview and Layout panels to quickly view the various templates as you drag the cursor over the template names.

Grid or Picture Package Templates

In the Lightroom Print module you can take advantage of the Grid or Picture Package templates. They offer you different functionalities for printing. Use a Grid template to print one or more photos in a standard grid layout, or use a Picture Package template to print one photo in a more flexible and freeform layout that can be manually adjusted. This can be helpful to print one image in multiple sizes for a client. To learn more about Grid and Picture Package templates, see Techniques #91–#93, later in this chapter.

Figure 87b After you have selected a template your image will appear with it in the main window.

After you have selected a template you may find it helpful to customize the layout by using the panels on the right (this will be discussed in detail in the subsequent techniques). Once you have finished customizing the layout, you can save it as a custom template. Simply click the plus (+) icon and give the template a new name, select where you would like to save it, and press Create.

#**88** Getting Started with a Contact Sheet Grid

One of the photographer's most common printing necessities is to create a contact sheet. Contact sheets allow you to print a grid of many thumbnails on one page. Photographers frequently create contact sheets to review images or to create a visual catalog to keep on a CD, DVD, or hard drive. This visual catalog allows you to "access" the images without having to browse the media storage device.

Creating contact sheets is an integral step in most workflows, and the good news is that Lightroom makes the process simple. To create a contact sheet grid, select multiple images in the Library module or in the Filmstrip (**Figure 88a**). Choose one of the two Contact Sheet templates in the Template panel (**Figure 88b**). The layout will appear in the main window (**Figure 88c**).

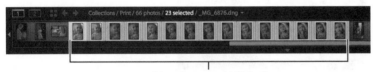

Selected images are highlighted

Figure 88a Select the images for the contact sheet from the Filmstrip.

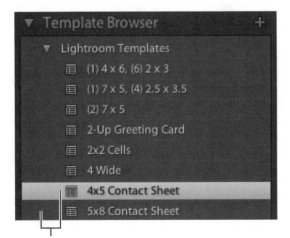

Contact sheet options

Figure 88b The two default contact sheet options are in the Template Browser. You can choose between a 4x5 and a 5x8 layout, depending on your needs.

Contact Sheets and Photo Archives Tip

Creating digital photo archives helps photographers simplify storage. It is easy to "lose" or forget which photos are stored where. You can use contact sheets to simplify the process. For example, if you burn images to a DVD, be sure to also create a contact sheet so that you can quickly browse the contents of the DVD without having to insert the DVD into a computer.

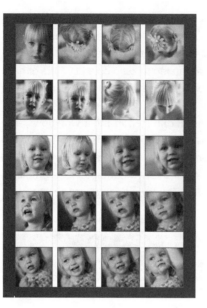

Figure 88c Here's a sample layout using the 4x5 Contact Sheet template.

#89 Customizing the Contact Sheet/Grid Image Settings

The Print module allows you to choose between two Layout Engines: Contact Sheet/Grid and Picture Package. The Grid layout is useful for creating and customizing layouts that fit within a rigid and traditional grid. To use this type of layout, select a Grid template (as described in Technique #88) or simply click on the Contact Sheet/Grid option in the Layout Engine panel (**Figure 89a**). Now that the Grid layout has been selected, let's examine how to further customize the settings using the Image Settings, Layout, and Guides panels.

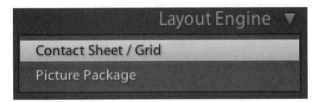

Figure 89a Select the Contact Sheet/Grid layout in the Layout Engine panel.

In the Image Settings panel (**Figure 89b**), select from the following options to suit your preference. Choose Zoom to Fill if you are not concerned about seeing the entire image and would prefer that the image fill the entire image cell. After choosing this option, position the cursor over the image and click and drag in order to change the part of the image that is shown (**Figure 89c**).

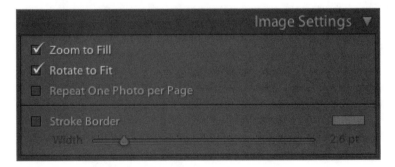

Figure 89b Choose Zoom to Fill to have the image fill the cell. Choose Rotate to Fit to view the largest possible image in the cell.

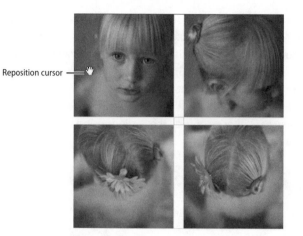

Reposition cursor

Figure 89c When using the Zoom to Fill option, hover the cursor over the image and then click-drag in order to position whichever portion of the image you want shown.

Next, choose Rotate to Fit to view the largest image that fits in the image cell, regardless of its horizontal or vertical orientation. As the name says, select Repeat One Photo per Page in order to create a contact sheet with one image per page. Next, choose Stroke Border in order to add a border. Click on the color chip to choose a new border color, and move the border sliders to change the size.

#90 Customizing the Contact Sheet/Grid Guides and Layout

The Contact Sheet/Grid layout can be fully customized using the Layout and Guides panels (**Figure 90a**). In the Guides panels click Show Guides and you will see the results in the main view area (**Figure 90b**). To learn how to use the guides, try clicking each guide on and off to see how it affects the display.

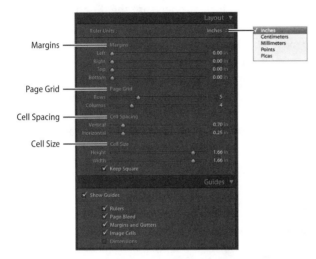

Margins
Page Grid
Cell Spacing
Cell Size

Figure 90a Use the Layout and Guide panels to make specific layout changes.

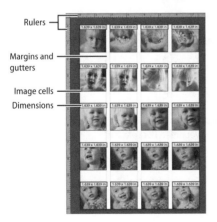

Rulers
Margins and gutters
Image cells
Dimensions

Figure 90b The guides allow you to see the various layout specifics. If you find any of the information distracting, simply click on the check box to disable the particular guide view.

Use the Layout panel to make specific adjustments to the layout (Figure 90a). If you have chosen to show the rulers in the Guides panel,

select an increment size. Typically inches works best, as most prints will be made to specific inch-sized papers.

Drag the controls to make the following layout modifications: Use Margins to control the margins surrounding the edges of the image layouts; use Page Grid to increase/decrease the number of rows and columns; use Cell Spacing to increase/decrease the distance between the images; use Cell Size to increase/decrease the image area; check Keep Square to make all cells perfectly square, or uncheck this option in order to create rectangular cells.

Finally, if you find the Layout panel sliders difficult to use, position the cursor over one of the following areas of the layout: Margins, Cell Spacing or Cell Size. Once you see the cursor change into a line with two arrows in the middle (**Figure 90c**), click and drag to resize that aspect of the layout.

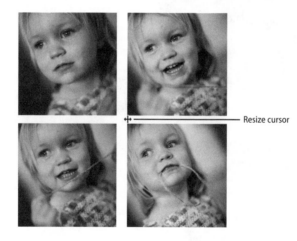

Resize cursor

Figure 90c If you prefer a more visual approach to customizing the layout, you can position your cursor over different aspects of the layout and click and drag.

#91 Picture Package Image Settings and Rulers

The Picture Package layout provides you with the ability to create a flexible layout for printing one photo on one or more pages. This type of layout can be especially helpful when you need to print one image in multiple sizes for a client. In order to use the Picture Package layout, first, in the Library module or in the Filmstrip select the image that you would like to use. Next, select a Picture Package template in the Template Browser panel of the Print module (**Figure 91a**) or click on the Picture Package option in the Layout Engine panel (**Figure 91b**).

Figure 91a Choose one of the first three Picture Package templates.

Figure 91b Use the Layout Engine panel to select Picture Package or to confirm what type of template that you have chosen.

Next, use the Image Settings and Rulers, Grid and Guides panels to begin to customize the layout (**Figure 91c**). In the Image Settings panel you can choose the following options:

Zoom to Fill if you are not concerned about seeing the entire image, but rather you prefer that the image fill the entire image cell.

Rotate to Fit in order to view the largest image that fits in the image cell regardless of its horizontal or vertical orientation.

Photo Border to add a specified width around each image.

Inner Stroke to add a color brush stroke around each image.

Note that as you increase the stroke width the image will scale to compensate the added width.

Figure 91c Use the Image Settings and Rulers, Grid & Guides panels in order to specify various layout options.

Next, modify the Rulers, Grid & Guides controls (**Figure 91d**) to change how the layout is displayed:

Ruler displays the Ruler and Units around the image layout.

Grid displays a grid behind the images and offers a Snap option so that the image cells snap to the grid or to other images.

Bleed displays a bleed area as a slightly grayed-out area around the edge of the layout.

Dimensions displays the image dimensions above each image.

Make sure Show Guides is ticked in the View menu for these guides to work.

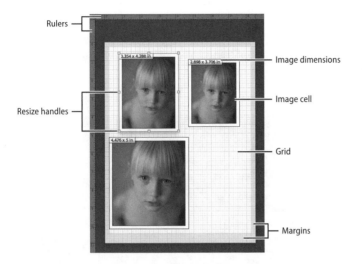

Figure 91d The Image Settings and Rulers, Grid & Guides options help you visually customize the layout.

#92 Picture Package Cells

The picture package Cells panel (**Figure 92a**) allows you to add images and customize images sizes in the layout. You can use the Picture Package layout to add as many cells as you want, and you can customize the layout arrangement in a wide range of configurations.

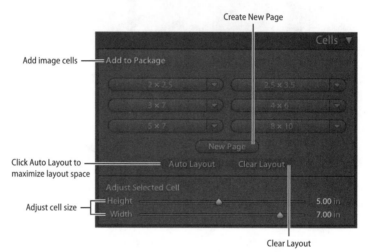

Create New Page

Add image cells —— Add to Package

Click Auto Layout to —— Auto Layout
maximize layout space

Adjust cell size —— Height 5.00 in
Width 7.00 in

Clear Layout

Figure 92a Use the Cells panel to add and adjust image cells to your Picture Package layout.

To use the Cell panel, click one of the buttons to add a cell to the layout. Choose from one of the six preset options. If the added cell doesn't fit on the page, Lightroom will automatically create a new page for the image. If you want to create a new page, click the New Page button. Next, click-drag the cell to reposition it on the page. To change the size of the image cell use the slider controls or click-drag one of the many resize handles (**Figure 92b**).

Resize handles

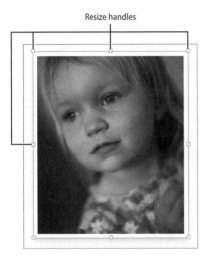

Figure 92b Use the handles to quickly resize an image cell.

Note
You can delete a cell by selecting it and pressing the delete key. To delete an entire page layout, click on the red "X" in the upper left corner.

Creating New Cells Quickly

One of the fastest ways to create a new image cell is to press Alt-drag (Windows) or Option-drag (Mac) to duplicate a cell. Another way to quickly create a new image cell is to drag and drop an image thumbnail from the Filmstrip below. Either way, the next step is to click-drag the cell to reposition or click-drag on one of the handles to resize.

#93 Adding Overlays

The Overlays panel (**Figure 93a**) can be used to add creative and/or technical information to either the Contact Sheet/Grid or Picture package print layouts (**Figure 93b**).

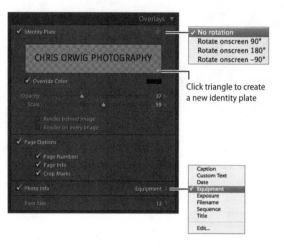

Figure 93a Use the Overlays panel to add an Identity Plate, Page Options, and Photo Info to your print layouts.

You can choose to add a personalized identity plate to the print layout by clicking on the Identity Plate option. To rotate the identity plate, click on the degrees icon in the upper left corner and choose an onscreen rotation option. To choose or create a new identity plate, click on the triangle icon in the bottom of the preview window. Next, choose Override Color to change the color of a text-based identity plate. Then you can modify the Opacity and Scale (or size) with the slider controls. In order to reposition the Identity Plate click and drag it in the main window area. Finally, you can choose to render the identity plate behind the image or choose to include it on every image.

The next two areas of the Overlays panel allow you to add Page Options and Photo Info to the image. Page Options allow you to add Page Numbers and Page Info to the bottom of the layout. In addition you can add Crop Marks for easier trimming after the photo(s) has been printed. Next, choose Photo Info to display a range of information including: Caption, Custom Text, Date, Equipment, Exposure, File name, Sequence, and Title.

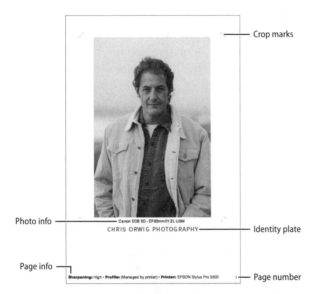

Crop marks

Photo info

Canon EOS 5D – EF85mm f/1.2L USM

CHRIS ORWIG PHOTOGRAPHY

Identity plate

Page info

Sharpening: High • **Profile:** (Managed by printer) • **Printer:** EPSON Stylus Pro 3800

Page number

Figure 93b The result of adding overlay information to the Fine Art Mat template.

Identity Plate

A well-designed identity plate, even if it is just based on type, can go a long way. If you haven't spent time customizing your identity plate be sure to do so. For more information on this topic see Technique #7. If you're a photographer and not sure how to design a logo, go to: www.pdnonline.com/gallery. View the PDN/Nikon Self Promotion award winners. Here you will find a great collection of photographs and well-designed marketing materials.

#94 Printing to JPEG or Printer

Lightroom provides you with all the printing controls to help create dynamic and stunning prints, whether or you are sending your images to a lab or printing them directly to a desktop printer.

Print to JPEG

To send your images to a lab, you will need to convert the files to JPEGs. Navigate to the Print Job panel (**Figure 94a**) and Choose Print to: JPEG File. Turn off Draft Mode Printing (unless, of course, you want to print preview-quality drafts of the images). Change the File Resolution by hovering the cursor over the resolution number. When the cursor becomes an icon with a hand and two arrows, click and drag to the left or right to decrease or increase the resolution.

Turn on Print Sharpening and choose Low, Standard, or High, and a Media Type (photo paper) of Matte or Glossy. Next, choose a JPEG Quality with the slider. Turn on Custom File Dimensions and hover the cursor over the file dimension numbers. When the cursor become an icon with a hand and two arrows, click and drag to the left or right to decrease or increase the dimensions. Finally, under Color Management, choose a color Profile and Rendering Intent by clicking on the menu options.

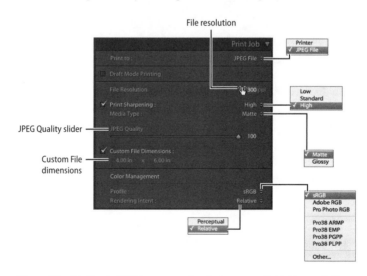

Figure 94a Printing to JPEG is a new option that comes with Lightroom 2. Use these controls to ensure the best quality when you are going to send the images to a lab to be printed.

16-Bit Printing on Mac

If you are running Mac OS 10.5 (Leopard) and have a 16-Bit printer, you can choose 16-Bit Output. However, if you select 16-Bit Output and Print to a Printer and your platform doesn't support 16-Bit, this will not adversely affect the quality of the print, but will slow the print speed down substantially—so use the 16-Bit printing option only if you are certain your printer has this capability.

Printing from Photoshop or Lightroom?

Until recently, I didn't use the printing capabilities in Lightroom very much; I completed most of my printing from Photoshop. Printing in Lightroom 2 is much better, and I now use Lightroom on a regular basis to create stunning prints.

Print to Printer

In the Print Job panel select Print to Printer (**Figure 94b**) for printing your images to a desktop printer. Choose Draft Mode Printing in order to speed up the process and save resources when printing low-quality contact sheets or prints.

Next, turn on Print Resolution and hover the cursor over the file resolution number. You can also type in any resolution between 72 and 480 ppi. When the cursor becomes an icon with a hand and two arrows, click and drag to the left or right to decrease or increase the resolution. Turn on Print Sharpening and choose Low, Standard, or High; select a Media Type of Matte or Glossy.

In the Color Management controls, select a Profile for the particular printer and type of media (For example, in the screen grab below, I have chosen a profile for the Epson 3800 Enhance matte paper). Choose a Rendering Intent of Relative or Perceptual. Typically, Relative will work best, so try that first. If you do not like the results try Perceptual. (For more information see the sidebar "Which Rendering Intent is Best?")

Which Rendering Intent is Best?

In Lightroom you can choose between Perceptual and Relative rendering intents. Choose Perceptual if you may have many out-of-gamut colors (colors that the printer can't reproduce), as this setting tries to preserve the visual relationship between colors. With Perceptual, out-of-gamut colors are shifted to colors that can be printed. Choose Relative when you have fewer colors that are out of gamut, as Relative rendering preserves all of the in-gamut color and shifts out-of-gamut colors to what it determines are the closest reproducible colors.

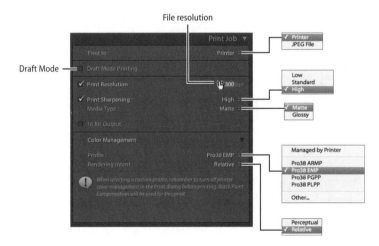

Figure 94b Use the Print to Printer option to ensure the highest-quality possible print when you are printing directly to a desktop printer.

Why Use Print Sharpening?

Use the Print Job panel to add Print Sharpening, based on the file's output resolution and media type. Keep in mind that Print Sharpening is added to any sharpening that you have previously done in the Develop module. In most cases, you will find that a Standard amount of Sharpening will work best. While the sharpening controls seem simple, keep in mind that the sharpening is of superior quality and is based on PixelGenius's PhotoKit Sharpener algorithms. Don't be fooled by the simplicity of the menu, as you will discover the sharpening results are stunning.

Web Module

As much as I love the speed and flexibility inherent in digital photography, I'm saddened that hard drives often become graveyards for so many digital photographs. I'm not talking about losing your images to a dead hard drive (see Technique #12 for details on backup strategies), but about the fact that many photographs are never seen or enjoyed again once they've been downloaded to a hard drive.

With the transition to digital, it seems that many of us have forgotten that photography should be about capturing a memory, telling a story, or sharing an experience. While I still have a soft spot for holding a stack of prints in my hand, let's explore how it's also possible to use the Web module for some really creative photographic sharing and storytelling.

#95 Web Interface and Shortcuts

As with other Lightroom module interfaces, the Web module interface is consistent and predictable, so you can find your way around quickly. Let's take a tour of the basics to get started (**Figure 95**).

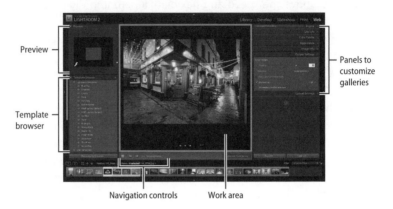

Preview

Template browser

Panels to customize galleries

Navigation controls Work area

Figure 95 The Web module interface closely mimics the layout of the Slideshow and Print modules, making it easy to switch back and forth between different parts of the application.

Template Browser—Hover your cursor over the Template Browser (on the left) to see the default templates in the Preview panel. Notice the icons in the bottom left corner of the Preview panel, which indicate whether a template uses an HTML or a Flash layout engine.

Work Area—the work area in the center of the screen shows an accurate preview of your current settings and even lets you edit various text labels for your galleries.

Navigation Controls—A few controls for this are found below the work area and function like the previous and next buttons in a Web browser.

Panels—There are seven panels on the right that you'll use to customize the layout and specify various export and upload settings. See Technique #97 for details.

Most of the work you'll do in the Web module is an interactive process of editing attributes and adjusting layouts. Here are a few keyboard shortcuts specific to the Web module that you might find helpful.

Key Command	Function
Control-Alt-P (Windows) / Command-Option-P (Mac)	Preview in Browser
Control-R (Windows) / Command-R (Mac)	Reload
Control-J (Windows) / Command-J (Mac)	Export Web photo gallery

#96 Using Web Templates

The Web module comes loaded with great templates for you to choose from, including a variety of HTML and Flash layouts. Even if you don't use an existing template, they're a great place to start to create your own designs. Follow these steps to create a Web gallery based on a template:

1. Select images in the Library module and switch over to the Web module, or select a collection of images in the Collections panel that you want to share on the Web.

2. With your images selected, hover your cursor over the various templates in the Template Browser on the left until you see something you like in the Preview pane.

3. Click the name of the template you want to use and watch in the work area as Lightroom renders the gallery design with your selected images (**Figure 96**). In the background, Lightroom generates all the HTML, JavaScript, Flash, and images that are necessary for your selected template. If you choose an HTML gallery and you have too many images to display on one page, Lightroom even generates the correct number of Web pages with the appropriate hyperlinks to present all your photos.

Figure 96 On Mac, the gallery previews in the work area are rendered with Safari. For Windows, the work area previews are rendered with the installed version of Internet Explorer.

4. To experience your Web gallery in a stand-alone Web browser click the Preview in Browser button at the bottom left of your screen, wait while Lightroom generates all the final images, and enjoy the full experience. If your Web browser displays a Flash warning dialog, rest assured that this warning only appears when you view the gallery from your local hard drive, not when you see it through the Internet.

Image Limit for Web Galleries with Flash

The Flash Web galleries generated by Lightroom are limited to 500 images per gallery. HTML galleries have no technical limit to the number of photos that can be included in a single gallery, but remember to be considerate of your viewers and their patience.

#97 Customizing Web Galleries

Templates are a great place to start your Web gallery design, but most photographers want to present their images in a unique way. If nothing else, you want your photo galleries to blend in with the look and feel of the rest of your site. You can customize your Web galleries in many ways using the panels on the right side of the Web module. Let's take a quick tour of some of the most important options.

Engine—The templates available in the Template Browser represent two Adobe layout engines, but there are actually three more third-party galleries included by default. This gives you a total of five different gallery styles for presenting your photos on the Web. Click on any of the options in the Engine panel to see a preview of your selected images with that design. The five engines include:

Airtight AutoViewer is a Flash-based gallery designed to display a linear sequence of images and captions as a hands-free experience for your visitor.

Airtight PostcardViewer is a Flash-based gallery that captures the real world experience of spreading out a bunch of photo prints in random order on a coffee table.

Airtight SimpleViewer is a Flash-based gallery with an elegant design, created as an alternative to some of the overdone Flash galleries we've all seen out there.

Lightroom Flash Gallery is the engine driving the various Flash-based gallery templates in the Template Browser.

Lightroom HTML Gallery generates simple HTML galleries that are represented by the HTML gallery templates in the Template Browser.

Site Info—The text fields in this panel represent the text on the pages of your Web galleries. The available fields vary slightly between the different layout engines, but the options, which include names such as Site, Title, and Contact Name, are pretty self-explanatory. For your convenience, click the small triangle next to each field name to reveal a list of recently-used text labels. This will save you from having to type your name and email address over and over again. In many cases, you can also edit the text right in the work area by double-clicking any of the placeholder text objects.

More Gallery Options

In addition to the five layout engines included with Lightroom, there's a third-party engine called SlideShowPro, which creates a few galleries that are quite popular. It costs a little extra, but the results are really impressive, and it integrates seamlessly with Lightroom. Details can be found at http://slideshowpro.net. Also check out the gallery resources at http://lightroom-blog.com/2008/05/gallery-resources.html.

Color Palette—The number of customizations you can make depends on which layout engine you've selected in the Engine panel. To change a color, click the color chip to reveal the color picker, and move the slider on the right to adjust saturation. Then click with the eyedropper anywhere in the color field to select a color (**Figure 97a**). If the descriptions for each color swatch aren't completely obvious, just watch the work area as you experiment and you'll see real-time updates to your color scheme.

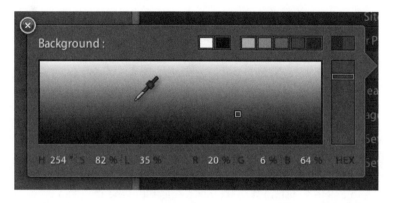

Figure 97a Use the pop-up color picker to customize the color theme for your Web gallery.

Appearance—The Appearance panel controls layout attributes such as the number of rows and columns in your thumbnail layout, and image attributes including borders and drop shadows. The available options will depend on the layout engine you select, so experiment with the controls and watch the preview in the work area.

Image Info—With the settings in this panel, you can display image titles and captions for the large view of your images. See Technique #98 for more details.

Output Settings—Use the Output Settings panel to control a variety of options, including image size, image quality, watermarks, and sharpening. See Technique #93 for a thorough rundown of the options available for each layout engine.

Upload Settings—Because the point of creating Web galleries is to share your work with the world, you can use the Upload Settings panel to upload your completed galleries directly to your Web server. No other software is needed to post your galleries. See Technique #99 for details.

Saving Templates

Once you've gone to the bother of customizing all of these options, you should save your settings as a custom template so it's easy to re-use your design in the future. Click the plus (+) icon in the Template Browser panel, give your template a memorable name, and save it in the User Templates folder or a new folder of your choice. Now you can create new Web galleries with the same design with just a click (**Figure 97b**).

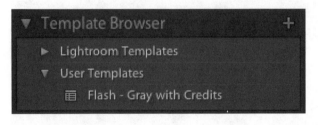

Figure 97b Save your custom templates in your user folder. If you have a lot of custom templates, organize them in subfolders.

To delete a custom Web template, select it in the Template Browser and click the minus icon. To update a Web gallery template instead of creating a new one, right-click (Windows) or Control-click (Mac) on the name of your template and choose Update with Current Settings from the context menu.

Saving Output Creations

One of the best new features in Lightroom 2 is the ability to save a special kind of collection called an output creation. This is like a template in that it captures all your custom Web gallery settings, but it also remembers which images are in your gallery. This makes it easy to recreate a gallery or update an existing gallery with a few new photos. After you've selected your images and customized your Web gallery options, click the arrow icon in the Collections panel to reveal the New Collection pull-down menu and choose Create Web Gallery. The rest of the process should be pretty obvious because it follows the same steps described back in Technique #82 for creating new Slideshows.

#98 Displaying Image Titles and Captions

Displaying your large gallery images with titles and thumbnails can help tell a compelling story or explain the context of a photograph to your viewer. To streamline the process of labeling the photographs in your Web gallery, Lightroom takes advantage of metadata that you should have entered back in the Library module (see Technique #39).

To control which text is used for titles and captions, open the Image Info panel in the Web module and customize the options to your liking. The default settings use the Title metadata field as a title above the image and the Caption metadata field as a caption below the image, but you have lots of other options (**Figure 98a**).

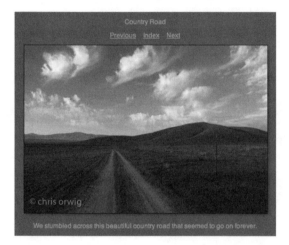

Figure 98a Using the Title and Caption fields for your image labels is just one more good reason to add metadata to your images in the Library module. The metadata will make it easier later to find your images and to make great Web galleries.

For starters, look in the pull-down menu to the right of each field in the Image Info panel. Some other options you can choose from include the date the photograph was taken, the equipment used to capture the image (including camera body and lens), and the filename. Choose whatever option you want, or uncheck the Title or Caption fields if you don't want those labels to appear. If you want the same label for every large image, choose the Custom Text option and enter your label in the Custom Text field.

If you want to be even more creative about the labels displayed with your images, choose the Edit command in the pull-down menu and use the Text Template Editor to create a custom label. Use the various pull-down menus in this dialog to create custom labels for your images. With dozens of samples spread across categories, including Image Name, Numbering, EXIF data, and IPTC data, you can come up with some really creative combinations—such as the one depicted in the following screenshot (**Figure 98b**). If you're fond of the combination you create, choose the Save Current Settings as New Preset command in the Preset pull-down menu at the top of the dialog.

Figure 98b In this example we've combined custom text with several IPTC location fields to tell the viewer where each photograph in a gallery was taken.

Note

Airtight AutoViewer and Airtight SimpleViewer are great galleries for telling a linear story based on your metadata captions.

#99 Defining Output Settings

The Output Settings panel in the Web module lets you control important settings such as the dimensions, sharpening, and compression quality of your gallery images. Considering that the whole purpose of the Web module is to create compelling presentations of your photographs, it's obviously worth your time to take a few moments to explore and understand the various settings. As with other functions in the Web module, the available options to work with depend on which layout engine you've chosen in the Engine panel. Let's take a tour through the options for each type of gallery.

Lightroom Flash Gallery and Lightroom HTML Gallery

The Quality slider is a typical JPEG compression option that lets you decrease image quality in exchange for smaller file sizes and faster download times. I tend to leave this at 65, but you should experiment to find the right compromise for your images in light of any Web server storage limits.

The Metadata option lets you choose between including all metadata (including keywords, descriptions, etc.) or just your copyright information. If you keep private or sensitive information in your metadata fields you should opt for the Copyright Only option.

Enable the Add Copyright Watermark option to burn your copyright statement into each large image in your Web gallery (**Figure 99**). This is a great way to remind visitors to respect your copyright and not steal your images. Don't worry though, these visible watermarks affect only your Web galleries, never the original catalog images. Keep in mind that adding a watermark is only possible if you have entered the copyright information in the Metadata panel in the Library module (see metadata information in Chapter 6).

Figure 99 The Copyright Watermark is an unobtrusive reminder to your viewers to do the right thing.

The Sharpening option is an easy way to keep your images looking good on the Web. You're probably shooting at very high resolution, and when you resize those images down to Web resolution you lose a lot of sharpness and detail. Experiment with the three options (Low, Standard, and High) to find the best results for your images, but note that as you use a higher sharpening setting, your gallery file sizes will be larger.

Airtight AutoViewer and Airtight PostcardViewer

These Airtight galleries have only two settings for their large images: Size and Quality. The effects are obvious, so just experiment until you find the right balance of image size, image quality, and file size. You might want to export the same gallery with different settings and compare file sizes if you're tight on space at your Web-hosting account.

Airtight SimpleViewer

This gallery also has Size and Quality sliders, which function in the same way as in the other layout engines. The Photo Borders option controls the white border around the large image, and the Padding option adjusts the space between the thumbnails and the large image. Last, there's a cool option labeled Allow right-click to open photos. This addresses one of the biggest nuisances of many Flash-based Web galleries, namely the inability to open just the JPEG image on its own. For example, if you post a SimpleViewer gallery of your kids for the grandparents, now Grandpa Pete can download the JPEG with a right-click and use the image as his desktop image. If, on the other hand, you don't want to make it any easier than necessary for others to download your images, just disable this option.

Note
For more information about the Airtight galleries visit: http://airtight interactive.com.

#100 Web Upload Settings

You can export your Web galleries to your local hard drive and upload them later with separate FTP client software, but when it comes to photographic workflow I'm all about doing as much work in as few steps as possible. So instead, use the integrated upload features of the Web module in Lightroom and save yourself some time.

In order to upload your Web galleries directly from Lightroom to your Web server, you need to tell Lightroom where to put those files. Follow these easy steps:

1. Choose the Edit command in the FTP Server pop-up menu in the Upload Settings panel.

2. In the Configure FTP File Transfer dialog enter your Server name, Username, and Password for the Web server to which you want to upload (**Figure 100a**).

Figure 100a Configure your FTP presets according to the login credentials supplied by your Web hosting provider.

3. Sometimes your Web site files need to go in a special folder on your server, so click the Browse button and navigate to the right folder. Browsing your Web server is also a great way to test your username and password.

4. If your server connection fails, you should contact your Web hosting provider and see if they offer special instructions for the three options, which are Protocol, Port, or Passive mode for data transfers.

5. When all the settings work as expected, choose Save Current Settings As New Preset from the Preset pull-down menu at the top of the dialog and give your preset a memorable name. If you regularly access multiple servers, go ahead and configure them now and give each preset a unique name.

When you're ready to upload a new gallery to your Web server all you have to do is choose the appropriate FTP preset from the FTP Server pop-up menu and click the Upload button in the right-hand corner of your screen.

For even more convenience, enable the Put in Subfolder option and create a new folder name each time you upload a new gallery to the same server (**Figure 100b**). This way each gallery will have a unique URL, such as www.domain.com/clientname, and you won't have to bother with editing FTP presets for each new gallery.

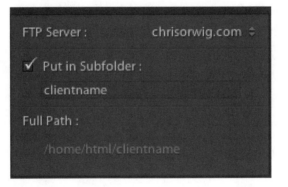

Figure 100b Use the Put in Subfolder option to upload different galleries to the same server with a minimum of inconvenience.

Index